IMAGES
of America

SOUTHERN
SAN JOAQUIN
VALLEY
SCENES

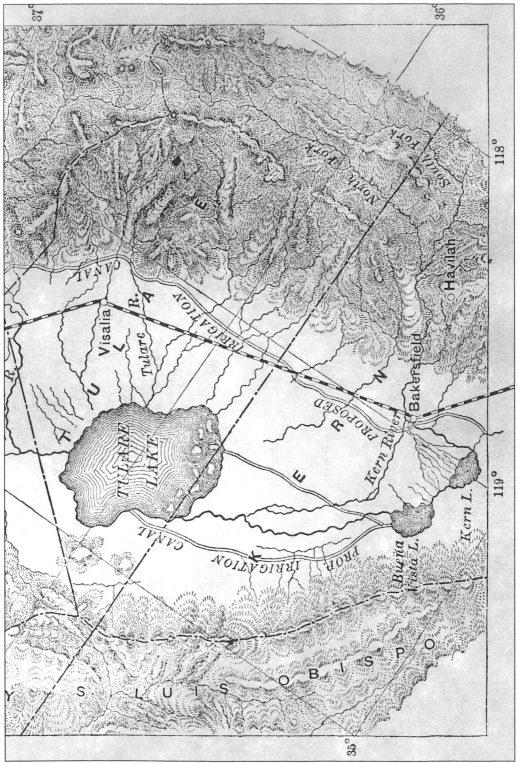

This image shows the Southern San Joaquin Valley as it was mapped in 1871.

IMAGES
of America

SOUTHERN
SAN JOAQUIN
VALLEY
SCENES

Chris Brewer

ARCADIA
PUBLISHING

ISBN 978-0-7385-0245-8

Published by Arcadia Publishing
Charleston, South Carolina

Printed in the United States of America

Library of Congress Catalog Card Number: 00-109611

For all general information contact Arcadia Publishing at:
Telephone 843-853-2070
Fax 843-853-0044
E-Mail sales@arcadiapublishing.com
For customer service and orders:
Toll-Free 1-888-313-2665

Visit us on the Internet at www.arcadiapublishing.com

CONTENTS

ACKNOWLEDGMENTS

Southern San Joaquin Valley Scenes contains nearly two hundred historic images of the great expanse of land known as the "fruit basket of the world." Noted photographers Carleton Watkins and C.A. Nelson took some of the photographs, while others were taken by everyday people as family mementos.

This book is not a running chronicle of the Southern San Joaquin Valley; it is, however, a glimpse of the valley's past, as seen by historians and other recorders of historical events. Images range from a simple streetscape of early Exeter to shots of *El Gobernador*, an early locomotive of the Southern Pacific Railroad. Stage depots, ranches, the rabbit drives of the 1890s, and the field workers of Kern County's colony ranches are also featured within these pages.

These images are reminders of the kind of life we lived in the Southern San Joaquin Valley. This book does not attempt to document all the important events that have shaped the valley, nor is it intended depict any specific chronology of events. It is a record of some of the interesting people, places, and things that made the valley what it is today, illustrated through historic images, some of which have never before been published. All of the photographs are special reminders of the great past of the Southern San Joaquin Valley.

This book is an effort on the part of a number of people who are dedicated to the preservation of history. Most of all, I must thank my wife, Sally, who has watched this project with great support and perhaps puzzlement as to why I did it. She has always supported my history habit, truly the only one I have. Honest! We have had a wonderful relationship over the years, and with her further patience, more of these photographic history books will follow.

I wish to express my sincere appreciation to Jim Pinkham, of Exeter, for all his diligent work in making me do this correctly. Jim is someone with a great gift for writing and editing. His work stands out in this book, where he picked apart every finite detail of my captions until they were correct. If I could can his talents and sell them, I'd be a rich man.

Joseph Cejka, pastor of the Exeter Presbyterian Church, is another individual who has assisted me in this endeavor. Joseph was the final proof editor, so if there is anything wrong with this book, well, you know whom to blame! Joseph worked diligently to perfect my work after Jim got through with me. My appreciation for both of them truly cannot be expressed.

Both were not only supportive of the work but came to the fore when the effort bogged down under the weight of the thousands of images that had to be reviewed and identified. They are good writers in their own right, and containing their exuberance toward the project was, in its own way, a special effort, especially with also having to deal with all my eccentricities. Special thanks goes to Exeter's May Marshall, who is a fine darkroom technician and without whose effort, the project would have been left short of usable images. Professional photographer Larry Lee, of Exeter, assisted in the technical support needed to complete the book. Shirley McFadzean, of Bakersfield, has, as always, been a special supporter of these projects.

Most of the images in this book came from the author's private collection; however, the special image collection of the late S.L. Douglass, of Exeter, was instrumental in providing imagery of the east side of the valley, especially in Tulare County. Bill Haffey, of Bakersfield, was also very helpful, providing imagery and great assistance. Many other history lovers also were kind enough to send their photographs to me for use in the project. Finally, special thanks to Shadow, my office cat, who shares a love of history and without whom I would have finished this book at a much more expedient pace.

PREFACE

With California joining the Union in 1850, the first legislature divided the state into 27 counties. It is fairly clear that the idea was to join the mass of votes in mining areas with areas that were almost entirely devoid of population in most of the San Joaquin Valley.

There were only two San Joaquin Valley counties in 1850, Tuolumne, centered about Sonora and Angels Camp, and Mariposa, which included all the land south of the Merced River, and a bit north of it also. This land bordered on the area known as the Southern mines. Mariposa County was so large that it contained today's counties of Mariposa, Madera, Merced, Fresno, Kings, Kern, and Tulare, as well as large parts of Mono and Inyo Counties and small parts of Los Angeles, San Bernardino, and San Benito Counties. Tulare County was cut out of Mariposa County in 1852, taking the area of what is now Tulare County and most of Kings and Kern Counties.

In 1852, a party from Mariposa and the Fresno River settlements, including the famous Major James Savage, rode on horseback to the designated locations of Poole's Ferry on the Kings River and Woodsville, in what is now Tulare County. Woodsville was about 7 miles east of what later became Visalia. A poll was set up, and the newcomers duly elected officers and established a county seat. Most returned to their homes in the north, leaving the new officers to run the county. Tulare County then extended as far northward as the San Joaquin River. The boundaries, as set forth by the legislature, were vaguely worded, and the new county included what is now the city of Fresno.

The first known American settlers in the Kaweah River Delta were members of the Woods party. They settled several miles up the Kaweah River from today's Visalia. Most were killed or run off by American Indians in January 1851. Loomis St. John, for whom the St. John River is named, also moved into the area, locating on that branch of the Kaweah. In the fall of 1851, C.R. Wingfield and A.A. Wingfield arrived from Mariposa and settled on the south bank of the Kaweah.

In December 1851, Nathaniel and Abner Vise came to what is now Visalia and built a log cabin on the north bank of Mill Creek. In 1852, bona fide settlers began to arrive in numbers, including Colonel Thomas Baker, later noted as the founder of Bakersfield. Because of the fear of American Indians, Baker built a stockade in the area where the Vise brothers were living. The board of supervisors first called the community Buena Vista, but the residents quickly changed the name to Visalia, after the Vise brothers. In 1853, after a bitter and much-contested election, the county seat was moved from Woodsville to Visalia, where it remains.

Tulare County has suffered loss of territory three times. The first was in 1856, when the northernmost portion was annexed to form a part of the newly created Fresno County. The second time was in 1866, when the southern area was removed as a part of the new Kern County. The third time was in 1893, when the West Side of the county was annexed to become Kings County.

In 1851, minor gold mining activities were beginning to crop up in the Kern County mountains. Thomas Fitzgerald arrived in the area before 1850, settling in what is now Glennville around 1853, where he built an adobe trading post. He was the first to drop down into the valley and build a permanent structure on Kern Island, now Bakersfield.

Not much was found in the placers, but quartz mining began in Keyesville on a substantial scale in 1853. Mining continued in the area, and Keyesville was at its pinnacle in 1857. In 1860, gold was discovered in the area of Kernville, or Whiskey Flat as it was known. In 1864, another strike was made, this time to the south, in an area named Havilah by a would-be gold miner named Asbury Harpending. Harpending later became notorious for salting the mines, working as a promoter of what became known as the "Great Diamond Hoax."

Havilah gold ore stamp mills crushed and produced ore as rich as $230 to the ton. In 1867, there were 25 stamp mills in the Kern area. By 1866, such an influx of population was seen that the legislature authorized the creation of Kern County, with Havilah as its county seat. Havilah gold strikes diminished, and the town's luster faded almost as fast as it appeared. Kern' s future was to be found on the plains of the Kern Delta.

The Kern Delta, or Kern Island, saw settlement by the early 1860s, and the area began to fill with squatters. Most settlers were just making do in a bare-bones lifestyle, while an early settler, John McCray, was able to bring blooded cattle into the delta. Meanwhile, large herds of wild horses were being caught by speculators and sold on the coast for $2.50 per head or more.

A massive flood of the Kern River in 1862 created a new channel for the Kern and actually cleared some of the swampland in the delta. In 1863, Col. Thomas Baker, who had been a United States land agent at Visalia, came to the Kern Delta. He eventually acquired a large area of land through what was known as the Montgomery Patent and began giving it away or selling it cheaply to those who would settle in the area.

In 1868, General Edward F. Beale acquired the famous Tejon land grant at the southern edge of the valley. In that same year, J.C. Crocker began what was to become Miller & Lux's initial developments in the Kern and Buena Vista lakes area, below Bakersfield. W.B. Carr, buying up cheap railroad land, began the formation of the great estate of Haggin & Tevis, or the Kern County Land Company. In 1870, Bakersfield was surveyed, and shade trees were planted. In the next year, residents of Bakersfield attempted to gain the county seat from Havilah but failed by ten votes. The issue arose again in 1874, and this time Bakersfield was successful.

Much of the history of Kern County involves the relationship of small settlers with the massive Kern County Land Company. Other issues include efforts to promote state water conservation and conveyance of additional irrigation water from the northern part of the state to the dry areas of Kern. Also important was the transformation of Kern's agrarian industry through the opening up of several huge oil fields. The discoveries of oil in Kern and Kings Counties coincided with the actual use of oil as a fuel in commercial equipment. The development of the industry in the southern valley caused a sudden boom in the economy, spurring on a huge cycle of development.

The legislative session of 1893 saw the last creation of new counties in the San Joaquin Valley. The part of Fresno County north and east of the San Joaquin River was set apart as Madera County. The western half of Tulare County was cut off to be Kings County. The latter was obviously named after the Kings River, which ran along a few miles of its northern line.

Curiously, the new county of Kings took over Tulare Lake, from which the mother county of Tulare was named. Within two years, however, Tulare Lake dried up from the lack of a continuous flow of water. This was caused by the massive irrigation canal projects that had sprung up in the southern valley. With the intermittent replenishment of water, the lake appeared to be dry by 1905 and was heavily settled and built upon. It flooded and filled up again in the wet season of 1908–09 but permanently dried up by 1915.

The tree-fruit farming area of the Lucerne Valley, or Mussel Slough, district initially supported Kings County's economy. It also had massive wheat farming around Tulare Lake. By 1929, the Kettleman Hills petroleum discoveries on the West Side added oil as a new commodity for the county. The oil was of such high volatility that it allowed drivers to put petroleum directly into their trucks.

Railroads in the southern valley included the Central Pacific Railroad, which bypassed Visalia in 1872, creating the new community of Tulare. Several early communities were bypassed by the railroad and later were linked by other lines. At one time, railroads connected virtually every community of any size in the southern valley.

The Southern San Joaquin Valley is rich in heritage and resources. Although for the most part an agricultural base, the economy of the area has always fluctuated with the weather patterns. In times of drought and flood, the economy may falter a bit, but it always rebounds into a healthy and viable economic base that has kept the southern San Joaquin Valley economically sound. The southern San Joaquin Valley is truly a remarkable place to live.

One

EARLY SCENES OF THE
SOUTHERN SAN JOAQUIN

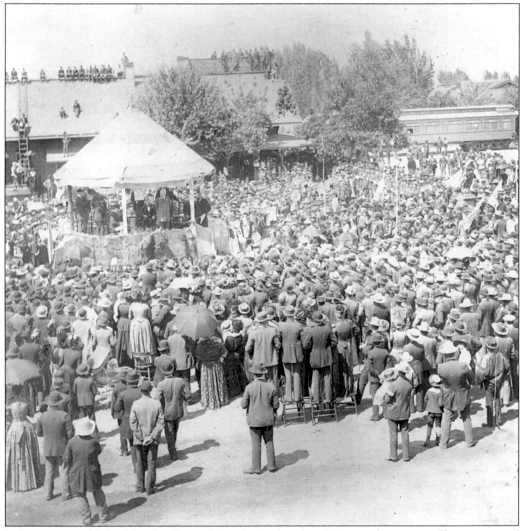

Tulare was established by the Central Pacific Railroad in 1872, with its post office instituted on December 31. During his whistle-stop tour of California in 1891, President William Henry Harrison stopped in Tulare on May 10th to give his stump speech to a large crowd. In this picture, he is standing at the front of the bandstand speaking to the crowd.

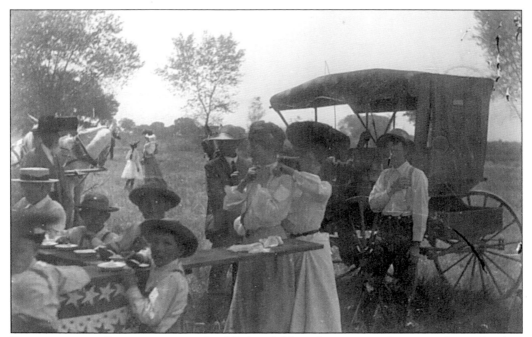

Panama is a small community south of Bakersfield, with its origin about a mile north of its present location. The original post office was established on June 24, 1874, and lasted for two years. Pictured here is a Fourth of July picnic in a field south of new Panama in 1904.

The Temblor Ranch house stood on the West Side foothills of Kern County. Surrounded by fig and cottonwood trees, the house was one of the last vestiges of the old foothill ranches that stood through the last part of the 19th century. The whole place went up in flames when a visitor threw a lighted match into some of the cottonwood lint, which then exploded in a flash. The house burned to the ground within an hour.

In the 1930s, the old hotel building at Rancho de los Californios and the Aguerre Store (in the background) were about all that was left of this 1820s rancho on the west side of the valley. Both were built in 1868, after logs from the Sierra washed down from a flood in the adjacent San Joaquin River. A sawmill was set up, and lumber was cut for the buildings. Several weeks after this photograph was taken, the buildings were consumed by fire.

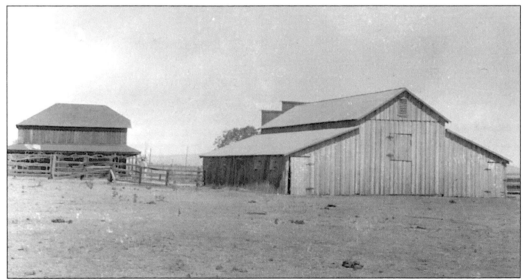

Many Overland Stage stations were located in the southern valley. Southern Kern County's Rose Station, pictured in this view looking west in 1930, was one of them. The stage road ran between the barn and station house. It was originally part of the Kanawha Ranch (pronounced "canoa"), which was named by William W. Hudson and James V. Rosemyre for the river in West Virginia. For a time, it was known as Hudson Station, and it was later renamed for William B. Rose, who was a station keeper in later years. A post office named Tejon was established in 1875. In 1877, it changed to Rose's Station, operating off and on until 1899, when it moved to Lebec. The property was annexed into the Tejon Ranch.

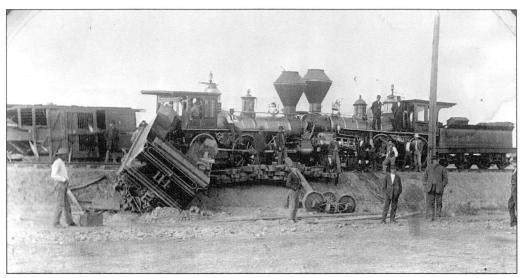

The first train wreck on the San Joaquin Valley Division of the Southern Pacific Railroad occurred at Tulare when a switch engine pulled into a main line directly in front of a freight train. Overland Stage driver Billy Brown, from whom the picture came, was driving the coach from Tailholt when he arrived at this scene, just in time for the railroad photographer to take the picture.

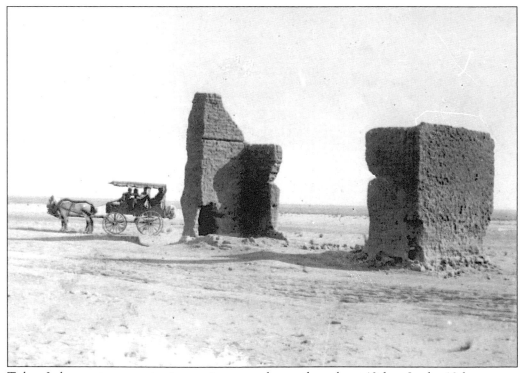

Tulare Lake was immense in size, yet it was no deeper than about 40 feet. In the 19th century, the area was settled and extensively used for transportation, fishing, and hunting. This 1881 photograph shows the ruins of the Two Adobes boat landing on Tulare Lake, near where the wild horse corrals were located. Tulare Lake is visible in the distance.

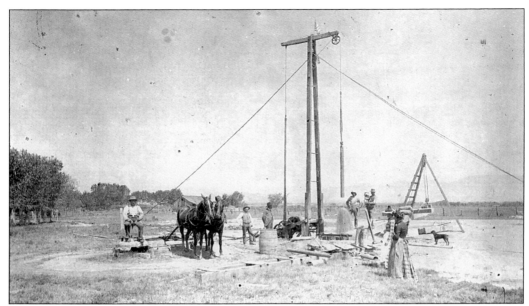

The Southern Pacific Railroad Company drilled the first artesian well in Tulare County south of Tipton. Artesians were sought after as early as 1859, but it took nearly 20 years to find the right strata. Artesian water flowed to the surface from a depth of 310 feet. The area was later planted with trees, and it became known as the Tree Ranch.

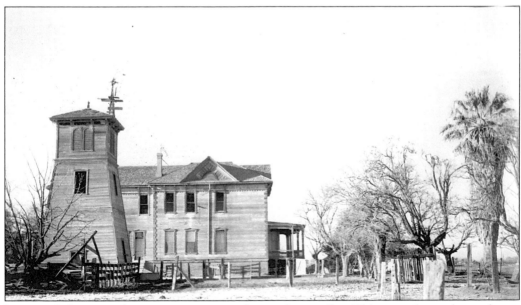

Large-scale homesteads were uncommon in the southern valley. This example was located near Tipton and belonged to Charles Burris, whose ancestors still reside in Tulare County. Sadly, the homestead shown was weathered and abandoned when this photograph was taken in the 1950s. Many of these relics of the past were eventually burned down or bulldozed to clear the land for more modern development.

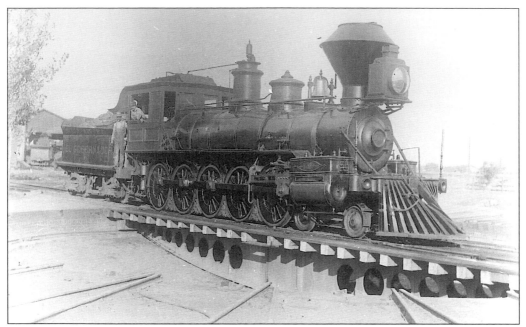

James Ben Ali Haggen and William Tevis of the Kern County Land Company hired Carleton Watkins to photograph their holdings. Connected with the Southern Pacific Railroad as part owners, they had a special train bring Watkins and his equipment to Bakersfield. *El Gobernador* was the engine and tender used to do this. It is pictured here on the Southern Pacific Railroad turntable in Kern City, now East Bakersfield, in 1888.

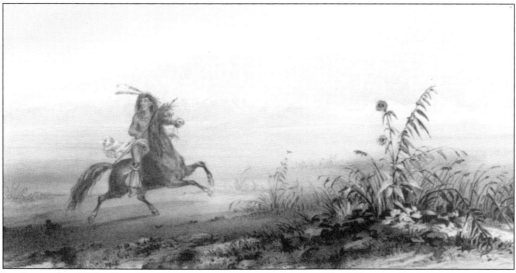

In the early 1850s, Congress sent a survey expedition into the West to determine what route would be best on which to construct a railroad line connecting the East Coast to the West Coast. Called the USPRR Survey, the team spent from 1853 through 1856 exploring and surveying several potential routes. This Hoer and Co. lithograph was produced as part of the survey, based on a sketch by Charles Koppel. It shows a local American Indian riding a spirited horse in the San Joaquin Valley. These lithographs were among the first images of life in the valley to be seen by the outside world.

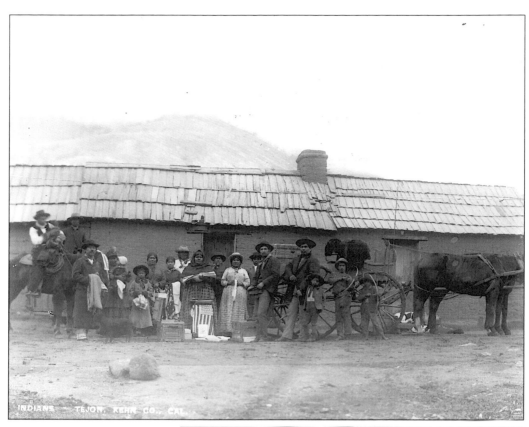

The American Indians at the Tejon Ranch were quite a sight when this photograph was taken in the late 19th century at a gathering in cool weather. Ready to go, with their trunks packed, several hold American flags, causing one to wonder about the event for which they are gathered. Of note is the lack of basketry that they were well known for creating.

Tejon basket makers Maria Sentada (left) and Eujenia Mendez display their wares, baskets that are now highly prized and sought after. The gaming tray on the right has a friendship design. The rattlesnake design is also visible here.

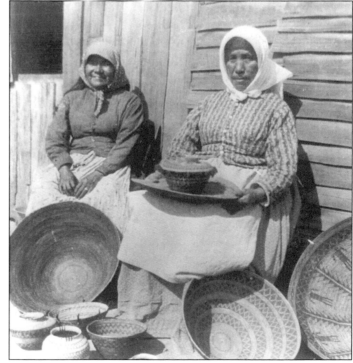

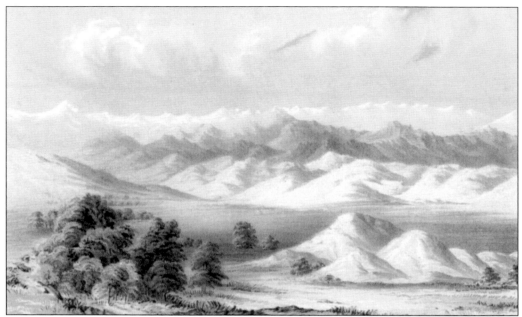

As part of the USPRR survey, sketches were made at various intervals depicting life in the area. This lithograph depicts the Sierra Nevada as seen from the Four Creeks area, near Visalia in Tulare County. Many of the peaks are identifiable, including Sawtooth and Homer's Nose.

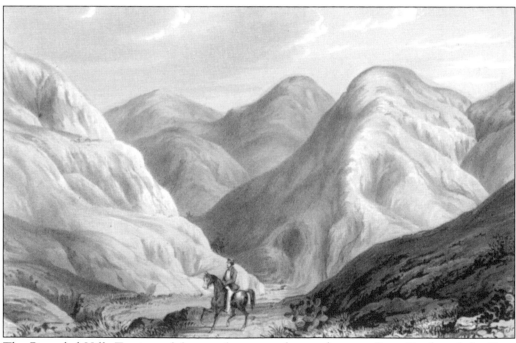

The Rounded Hills Tertiary of the area between what we know as Poso Creek and the Kern River is featured in this lithograph from the USPRR Survey of 1853–56. The image shows what the land appeared like 150 years ago, although it still looks the same today. This would be in the Mon Canyon area, south of Granite Station, where some of the most desolate land in the valley is to be found.

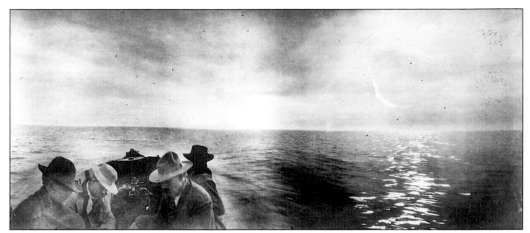

This intrepid bunch of men is boating on Tulare Lake in 1906, when it had once again filled. The lake's huge expanse is evident behind the men. Hunters like these used a boat to cross the lake to various islands and sloughs. L.M. Powell of Hanford took this photograph in 1906.

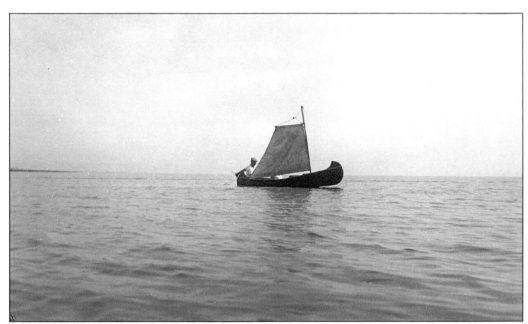

Although Tulare Lake was considered to be dry in 1915, there were periods when it began to look like the Tulare Lake of old. This is a 1937 photo of Frank Buckner of Hanford, sailing on Tulare Lake in April of 1937. The previous winter had been quite wet, and the water level of the lake was high. This picture was taken near the mouth of the Kings River.

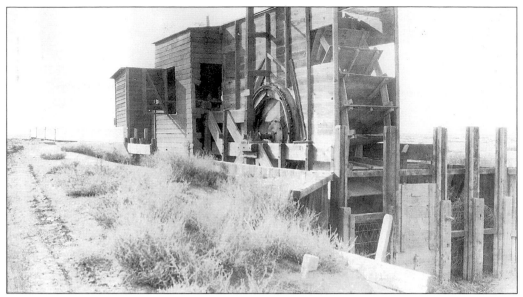

The W.H. Wilbur water wheel was built to pump water out of Tulare Lake and irrigate the surrounding lands. It was located approximately 8 miles south of Alpaugh and was one of the first plants to be built. It was still in existence in the mid-1930s when this photograph was taken.

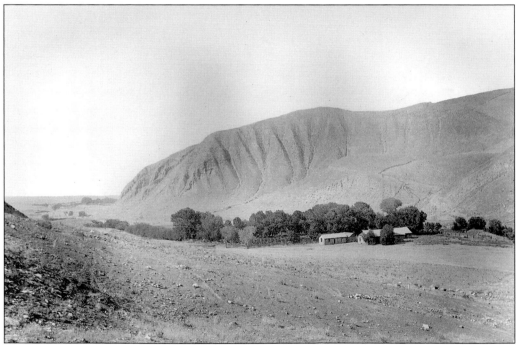

It is claimed that there was no Extensionada of the Santa Barbara Mission at San Emigdio, located at the southern end of the San Joaquin Valley; however, evidence exists of an adobe church at San Emigdio village. This photo of the ranch headquarters in the San Joaquin Valley was taken in the 1880s. Between 1881 and 1886, a post office, which is visible on the left, functioned at the site.

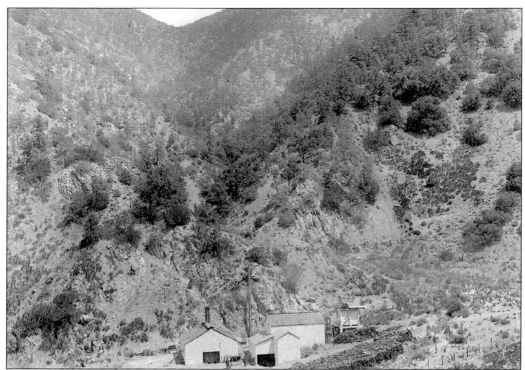

Mining was an important economic activity in Kern and Tulare Counties. The Antimony Mine at San Emigdio, located in the foothills at the southern end of the valley, was one of those unusual operations. This operation was active in the 19th century and produced moderately well for its operators.

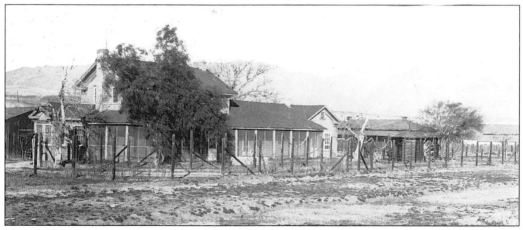

The old Rio Bravo ranch house, at the mouth of the Kern River Canyon, was one of the first buildings constructed in the far end of the southern valley. Built right after the flood of 1867, the house was, for a while, the home of the Jewett brothers and their early Kern County agricultural experiments. This house replaced an earlier adobe building that was washed away in the flood. On July 13, 1865, the notorious Mason and Henry Gang raided the ranch. Then, after having been fed supper, they killed a miner named Johnson. Philo D. Jewett was there but managed to escape. The Jewetts later moved north of Bakersfield, where they farmed a sizeable area and continued their experiments in agriculture.

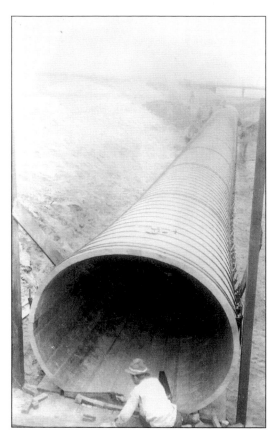

The Mount Poso Canal was an experiment in the movement of water in the foothills above Bakersfield. The half-million dollar boondoggle was intended to flume water down from upper Poso Creek into the area now known as Famoso. Proposed in 1888, construction started in 1890. It ran 40 miles, sometimes through solid granite, and much of it was constructed of redwood planks. This is a photograph of one of the siphons of the canal, made of redwood. As fate would have it, just before the project was finished, a devastating cloudburst caused much of the canal bank to wash out. It is also said that disgruntled locals, not wishing to lose their water, dynamited key areas of the upper channel. The Kern County Land Company successfully filed an injunction claiming ownership to all the water of Poso Creek, causing the canal's ultimate demise.

This photo shows one of the sections of the Mount Poso Canal in 1940. This section is constructed of redwood pipes, which carried the water. Much of the redwood from the flume and siphon pipes was removed when the project failed, and it was used to construct local barns and houses. The redwood structures are still in the Granite and Poso areas today.

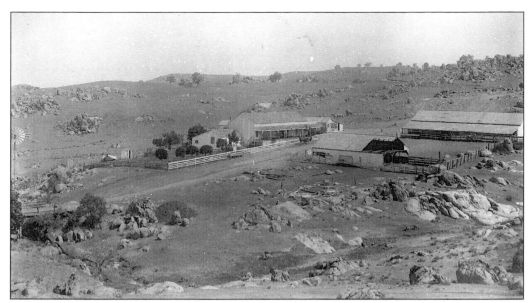

Granite Station was not a late 1850s Butterfield Stage Lines stop, as many believe. It was, however, built during the early 1870s as a stage stop between Linn's Valley and Bakersfield. The post office was established on December 17, 1875, and closed on October 24, 1876. Granite Station was named after the large granite outcroppings in the area. It was also known as Elmer, named after Elmer Bohna, whose family settled in the area earlier in Kern County's history. The Elmer Post Office was established May 23, 1890, and closed May 20, 1892. It was reestablished on June 6, 1900, and closed May 14, 1914. The Granite Station building was a local landmark into the 1980s, when it mysteriously burned.

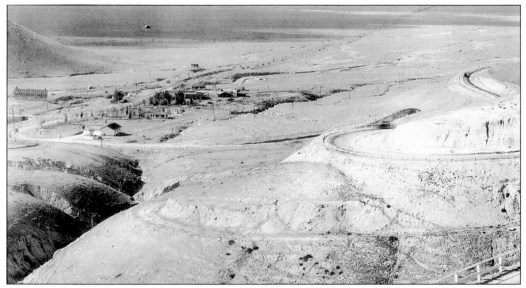

The Grapevine Grade was part of a notoriously dangerous road connecting Bakersfield to Los Angeles. The highway, winding its way down the mountain ridge, contained both northbound and southbound lanes but no separation between the two. In the distance, to the left, is the Wheeler Ridge Oil Field; on the right, at center, the Sinks of Uvas Creek is visible. The faint road under the highway is the perilous old wagon road used in the 19th century.

Kingston Cal Sep 8 1869

Received at San Francisco, *Sep 8 1869 10 M.*

To *Charles Lux*

*Send Five hundred 500
dollars by Express tomorrows
Stage*

Henry Miller

8 paid 300

Huge land holdings and water rights will frequently be topics of conversation among local historians. This is a Western Union Telegraph from Henry Miller to his partner Charles Lux, asking for $500 to be sent via stage express. Miller and Lux were partners in one of the largest land holdings in California. It was said the Miller and Lux ranches stretched from one end of the valley to the other and that one could travel the entire distance without leaving the property.

Two

CORNUCOPIA, THE FRUITED PLAIN

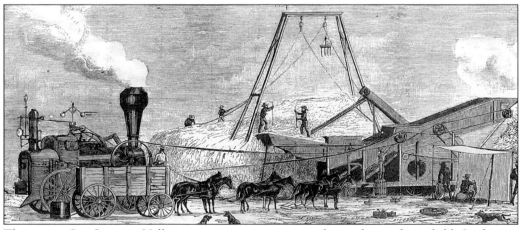

The entire San Joaquin Valley was, at one time or another, a huge wheat field. In fact, it looked like a vast sea of wheat. This 1888 etching from *Scientific American* shows the process of threshing the wheat in July. By this time, steam power was used to drive larger equipment, and the job was made somewhat easier. This was a common scene in the San Joaquin Valley.

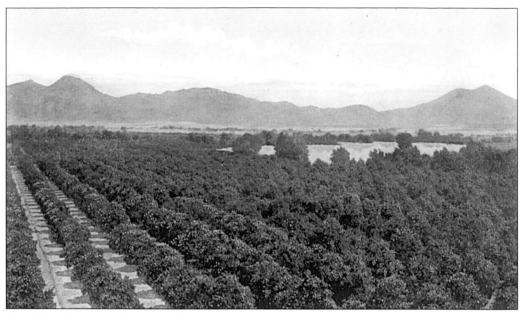

The Woodlake area has been planted with citrus since the turn of the century. This excellent image of the area was taken around 1915. Note the body of water, which comes from the St. Johns River.

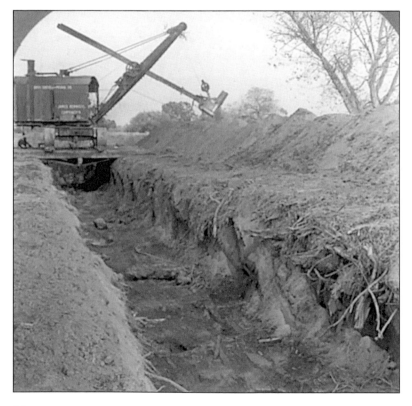

Like nearly all communities on the east side of the southern San Joaquin Valley, Lindsay is a community in constant need of a good water supply for agriculture and domestic use. This Rion Steam Shovel is digging one of the local canals at Lindsay in a slow methodical manner. It moved down the canal by rolling onto beams that were placed across the canal banks. James Kennedy was the contractor on this project, which was east of town.

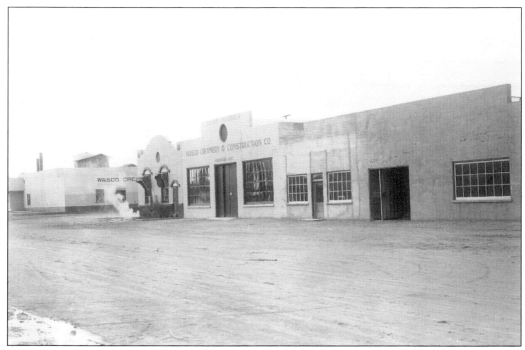

The Wasco Creamery at Fifth and G Streets was one of the mainstays of the community, and this 1925 photograph shows part of the facility. H.G. Hull and his partners built it in 1912 to provide an adequate outlet for dairy farmers in the area. It was closed down after a union impasse blocked the creamery's trucks from crossing the ridge route into Los Angeles. Pacific Yeast Products, later the Biofirm, took over some of the facility. Harry Pollack's DeSoto dealership and Harry Scaroni's Wasco Ice Plant were also located in the plant.

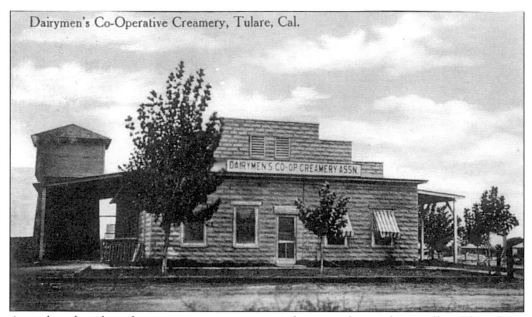

As with today, dairy farming was an important industry in the southern valley. This photo shows the Dairymen's Cooperative Creamery in Tulare, as it looked in 1916.

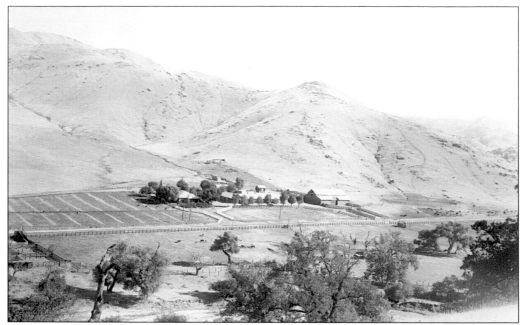

The Adolph Gill Ranch, in the Yokohl Valley, was headquarters for one of the largest cattle ranches in California. At one time, the Gills had holdings up and down the state. The Yokohl Valley, east of Exeter, is a fertile area well suited for cattle. From 1883 to 1898, it had an active post office. This photo of the ranch, taken from Rocky Hill, shows the well-organized and neatly groomed facility.

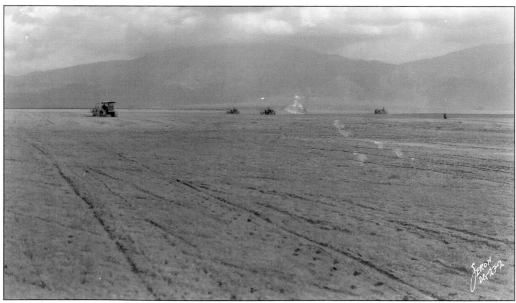

Back in the 1920s and 1930s, Joseph DiGiorgio owned a great deal of land in the Arvin area. His company still has holdings in this area and many others. In this 1923 view north of Arvin, the company is leveling land prior to planting grapes. DiGiorgio was responsible for the clearing and planting of thousands of acres in the area. The company built small communities, with worker housing and packing sheds, north of Arvin and in Delano.

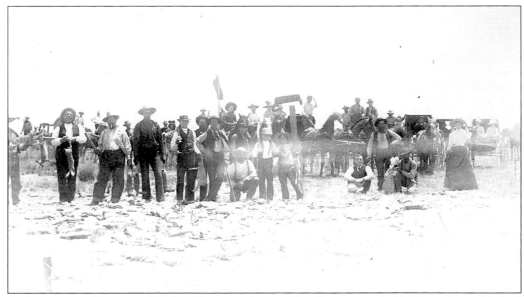

Pixley was another area of Tulare County where rabbit drives were held. Though established in 1872 when the Central Pacific Railroad came through, it was actually founded in 1886 for the Pixley Townsite Company. This view of Smith Ranch, 3 miles west of Pixley, shows the result of one of the rabbit drives held in 1887. Few would understand this activity in today's civilized world.

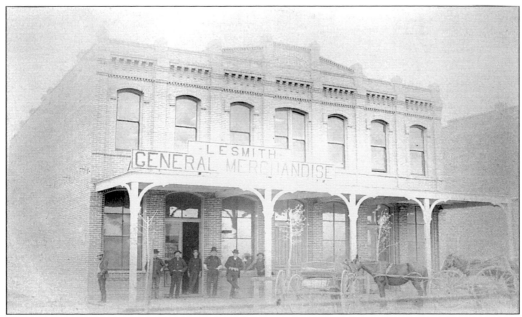

Pixley was founded near the end of the 19th century, with its post office established on June 3, 1887. The L.E. Smith General Merchandise Store was located in Pixley, north of Delano. Pixley was a booming community in the 1880s, with the railroad passing through several times a day.

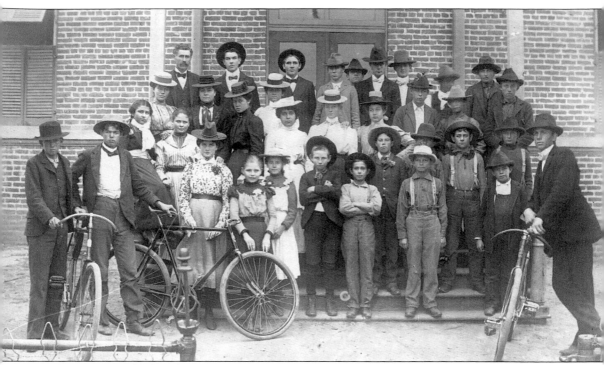

Delano was established by the Central Pacific Railroad in 1873. Its post office was opened on October 21, 1874. Schools were important to the community, and in Delano, the school handled a wide range of ages. This is a photograph of the Delano School's 1897 graduation, with Mr. Mercer, the teacher, pictured in the top row.

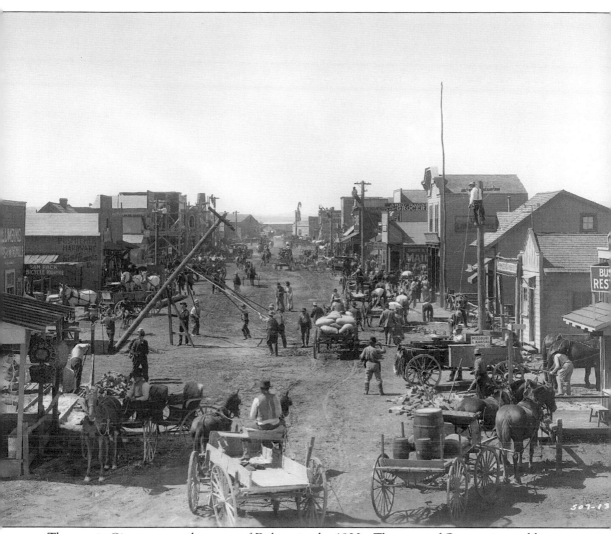

The movie *Cimarron* was shot west of Delano in the 1920s. The town of Osage, pictured here, was created in the flat lands to depict the boom period of Oklahoma.

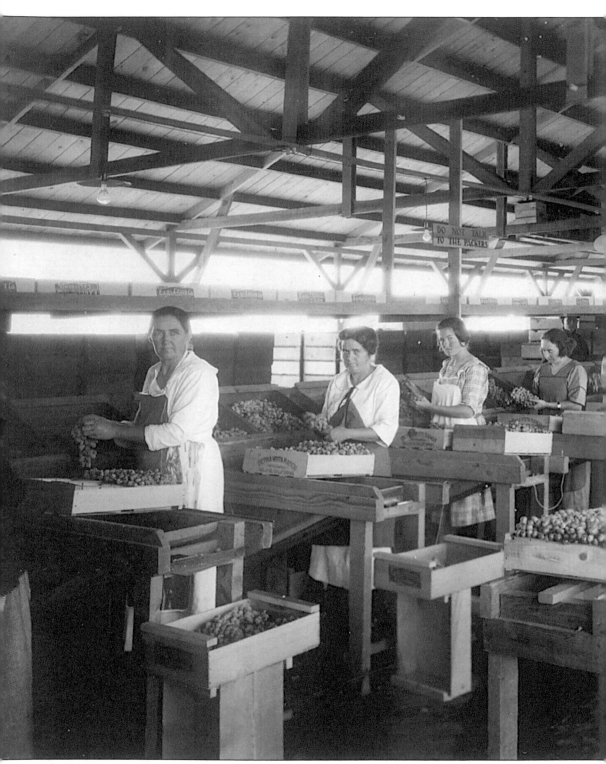

The DiGiorgio grape shed was a booming place in the grape season. In this 1923 photograph of the packing line at the shed, the crew packs fruit for DiGiorgio's Sierra Vista Ranch in Delano.

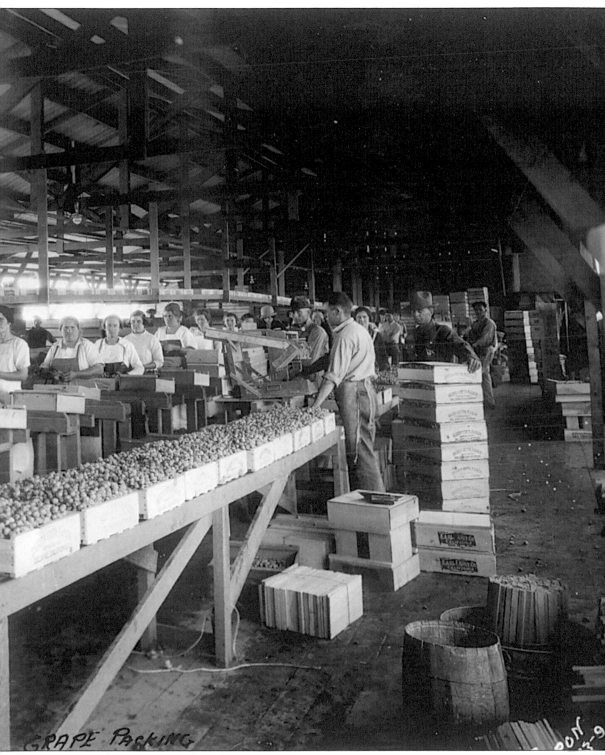

GRAPE PACKING

It appears that they are packing Emperor Grapes.

Lerdo Station in Kern County was nothing more than a loading dock and a shack, though it had a post office from 1890 to 1893. This is a photograph of the station as seen before 1930. The posts on the loading dock ramp are identifier markers, which read "Railroad Property," that were placed along the line.

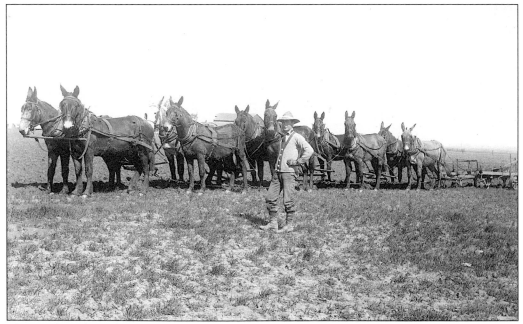

This is a long-line plow team working the farmland in Kings County, a typical scene all around the agricultural areas of the valley. From the looks of it, they appear to be working pretty hard to plow up the soil.

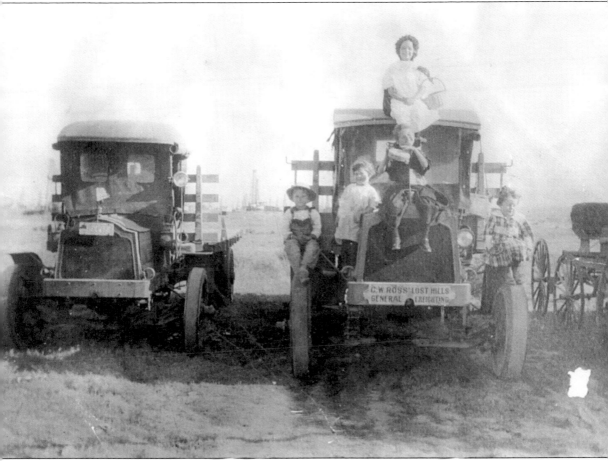

J.H. McMillan had 40 eight-mule teams working the West Side. After the teams were taken off, C.W. Ross came in with trucks, delivering from 30 to 40 tons of freight each day to the Lost Hills area. This photograph shows a couple of his trucks; the one on the left is a 3-ton Packard, and the center one is a 6-ton Packard. Veronia Smith and her brother sit on its right fender, while Helen Barrows sits on the left fender next to her sisters. The buggy on the right was used to deliver ice, groceries, and meat to families in the area.

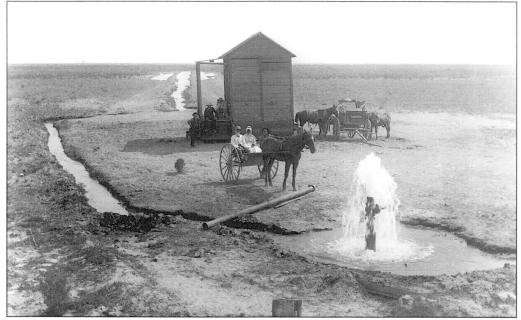

Artesians were not limited to Tulare County—Kings and Kern Counties had their share, too. This late 1880s photograph features a Kern County artesian well dug and used for irrigation. Primitive as they were, the irrigation systems were able to deliver water to some of the parched desert-like areas of the southern valley.

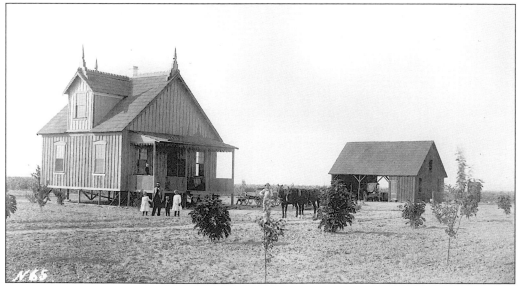

The Thiesen farm in the Rosedale Colony is pictured here in October 1890. The family settled their farm in April of the same year during the early days of Kern County's Rosedale Colony. In 1890, the Kern County Land Company created the colony in a desolate place with little water. In fact, the huge Calloway Canal ran right through the colony, but its water could not be used due to legal water rights issues. Rosedale's post office operated from 1891 to 1913, and the community became known as the English Colony due to English settlers purchasing land there. The colony eventually failed due to the lack of water and poor farming practices.

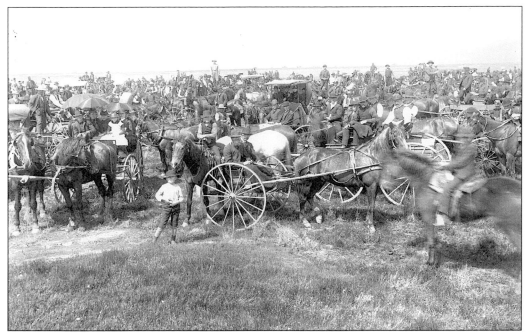

In 1890, rabbits had become quite a problem for the residents living in the southern valley. This scene at Goshen shows the preparation for a rabbit drive. A fairly large assemblage was gathered with clubs and whatever other hand-held weapons were available. The group moved into an area and literally herded jackrabbits into a fenced corral to dispatch them. Gruesome as it was, it at least appeased the local population to know that those in charge were doing something to keep the rabbit population down.

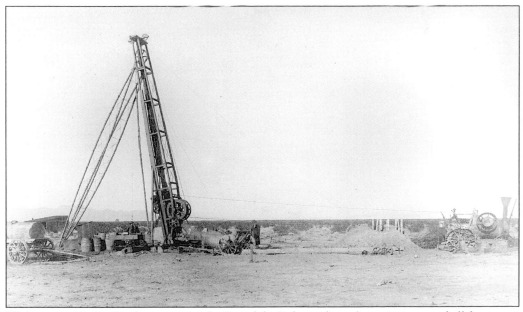

With a noted lack of surface water in the Rosedale Colony, the only option was to drill for water. There was some consideration that artesian wells could be drilled in the area. This drilling rig operated with the hope of striking water at a reasonable depth.

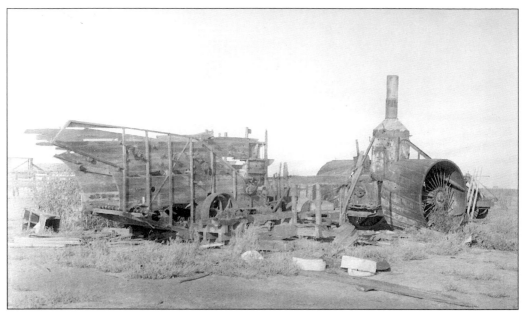

Tulare Lake flooded very quickly, and often, equipment was left behind in the effort to escape the flood waters. This Daniel Best Steam Tractor was submerged when the lake flooded in 1906. It was still sitting in the same location in 1935. These tractors were used for farming the massive wheat crops grown on the West Side.

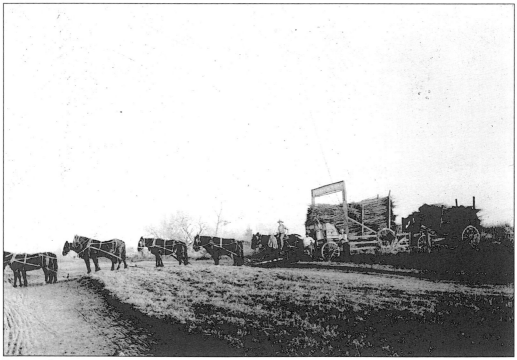

Fruit and nut tree stock were grown in nurseries, then transported to orchards for planting. This late 1880s photograph shows D.M. Pyle, Elmo Pyle, and George Peoples moving tree stock from the Pylema Nursery, near old Panama, south of Bakersfield.

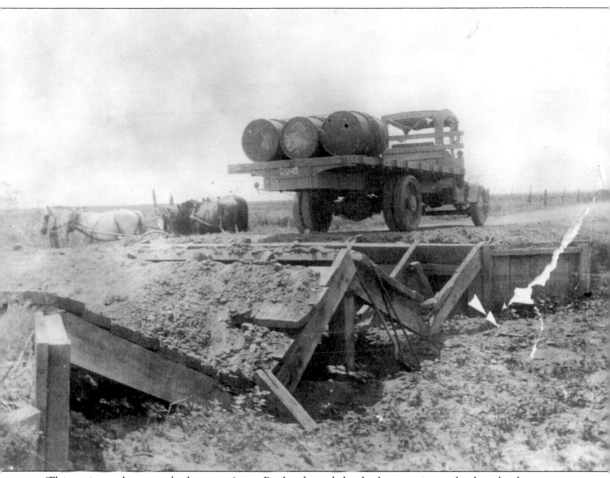

This unique photograph shows a 6-ton Packard truck backed up against a broken bridge near the Tracy Ranch close to Buttonwillow. The truck was loaded and going the opposite way when the bridge gave way. A salesman who was sitting on some drums in the back of the truck was thrown completely off the truck and into the ditch when the bridge broke.

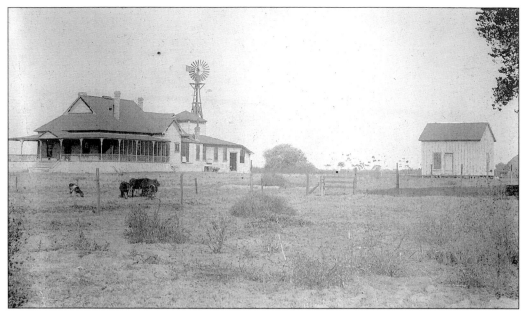

The Pyle Ranch house, called Pylema, was situated south of Bakersfield near Panama and was a substantial structure for its day. This photo shows the house and nearby bunkhouse for the ranch hands, as seen in 1891. An addition, seen at the rear, was built on the back of the house, attaching the tank house and windmill.

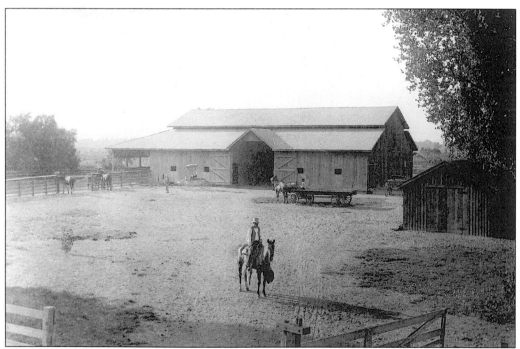

As a working ranch, the Panama Ranch was fully equipped to handle stock, as is seen in this photograph of the hay barn and corral. The ranch, like many of the Kern County Land Company ranches, produced its own hay and feed for the livestock. This 1880s photograph also shows the natural haziness of the Kern Delta, even in the 19th century.

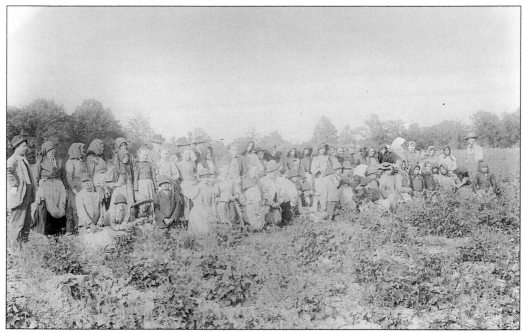

Field workers are nothing new to the San Joaquin Valley. Pickers, mostly women and children, gathered here momentarily for the photograph, soon to return to work in the field. This image demonstrates how tough life could be on the plains of the Southern San Joaquin Valley. Taken around Panama, south of Bakersfield, in 1895, it is a profound reminder of the labor-intensive work involved in agriculture.

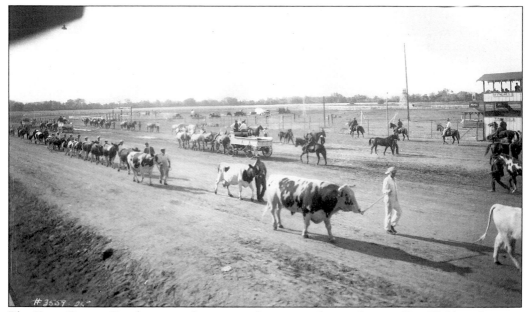

The Kern County Fair became a huge annual event in the southern valley. Held at the new fairgrounds north of Bakersfield, the fair drew people from all over. This 1925 photo shows the parade of livestock passing in review for judging. The fair operated at this location until well after World War II, at which time it was relocated to south Bakersfield.

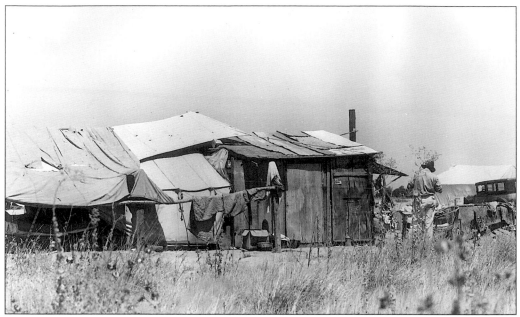

The 1930s saw a great influx of people from Kansas, Missouri, Texas, and Oklahoma, among other states. The Dust Bowl of the mid-1930s caused the migration of thousands of families to the San Joaquin Valley. This is a photograph of a campsite, pitched at the edge of a cotton field south of Bakersfield. As seen here, anything available was used for shelter.

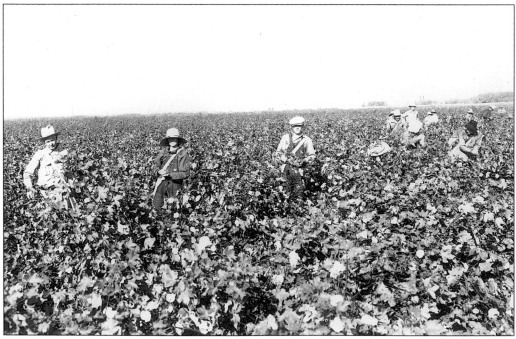

This is a crew of cotton pickers in the fields near Buttonwillow. This Depression-era crew works its way through the field, picking the bolls that are ready to harvest. Taken on October 26, 1937, the photograph shows how a large workforce got through the fields prior to the advent of the cotton-picking machines.

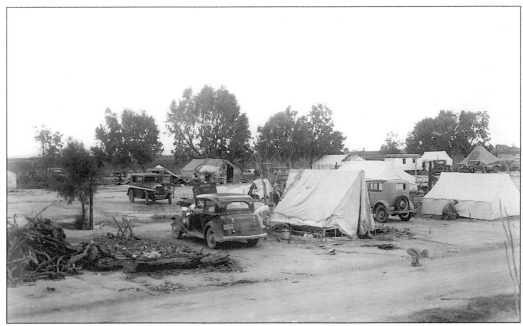

Migrant camps were temporary at best. This camp, south of Bakersfield, is in the midst of being rebuilt, just after an intense storm blew through. Tents were blown down, tree limbs were broken, and even the front tent site burned. This 1938 photograph depicts the rough conditions faced by many people who migrated to California at that time.

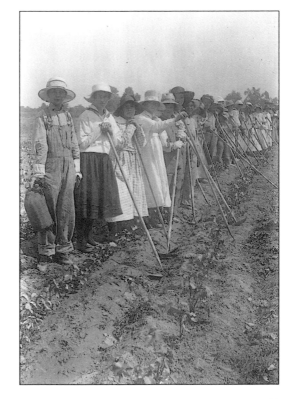

Labor crews included friends and family, as shown in this photograph taken in the teens. This weed-hoeing crew was formed just after the turn of the century. The apparel is fascinating, as it shows everything from coveralls to fairly nice dresses. Workers always wore hats to keep the hot valley sun from burning them.

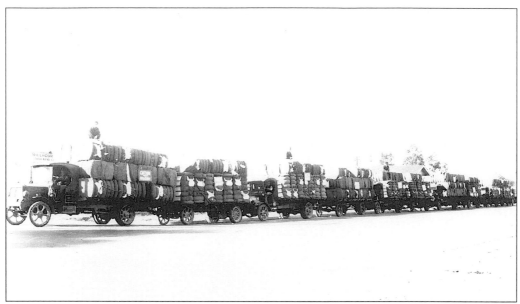

This rare photograph shows the way cotton was transported in the 1920s. Loaded and ready to take the baled cotton to market, the trucks probably went to Los Angeles over the twisting and winding Ridge Route. Note the solid rubber tires on the trucks. Although they lasted longer than pneumatic tube tires, the ride was just short of awful.

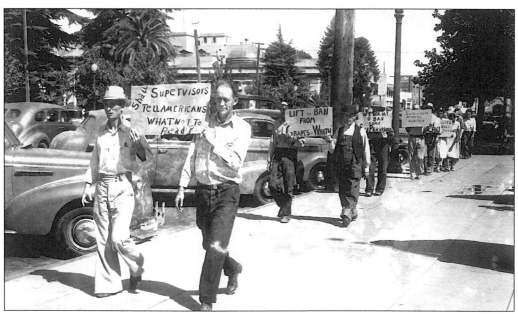

John Steinbeck published his epic, *The Grapes of Wrath*, in 1939, depicting the plight of migrant workers in the San Joaquin Valley. Many county governments took offense to the book, and some even banned it from their public libraries. Kern County was one such county to do so, going as far as to have an unofficial book burning behind the courthouse. In August 1939, protesters in front of the Kern County Courthouse picketed, demanding that the board of supervisors adhere to the Constitution, by upholding the right of free speech, and reinstate the book to the library system.

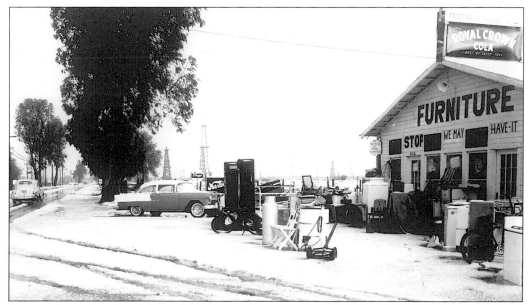

Frequently confused with Rosedale, Fruitvale is a small community located a couple of miles west of Bakersfield on Rosedale Highway. The town was founded in 1891 on land purchased from the Kern County Land Company. This mid-1950s photograph of the Fruitvale Furniture Store shows the unpredictable weather of the Central Valley. Snow is an unusual occurrence for this area; yet, as this image documents, it can snow and sleet in the valley.

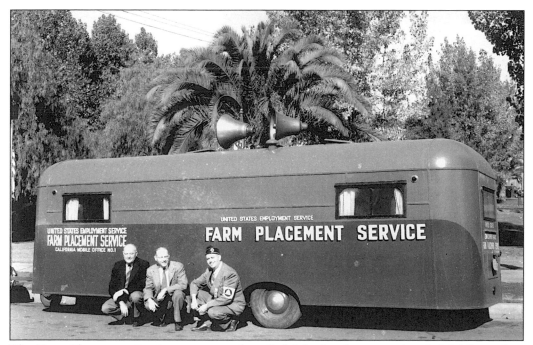

The Farm Placement Service was created to find jobs for the unemployed. Mobile trailers like this one were driven around the southern valley, serving the migrant population in the late 1930s. This photograph was taken in downtown Bakersfield, with the police department building in the far background.

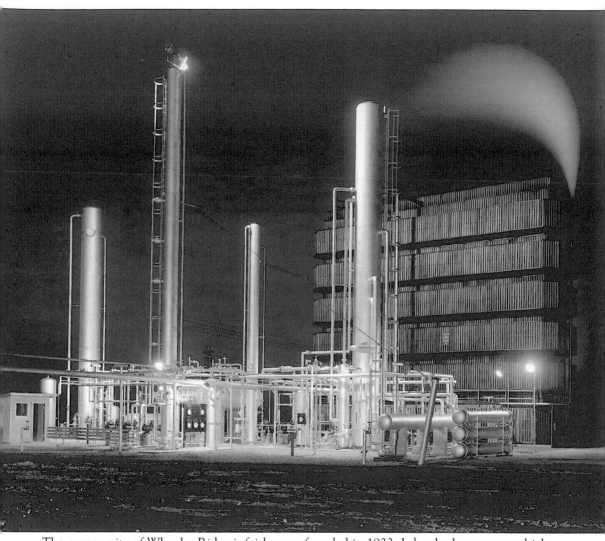

The community of Wheeler Ridge is fairly new, founded in 1923. It has had some pretty high-tech oil equipment operating over the years. The accrual Wheeler Ridge, which is in the nearby hills, was named after 19th-century government survey chief George Wheeler and the ridge on which it is located. The Rancho Gasoline, Parkhill Unit Cracking Plant with a Fluor Aerator, is seen here at night in November 1937.

Three

BLACK GOLD AND GOLD THIEVES

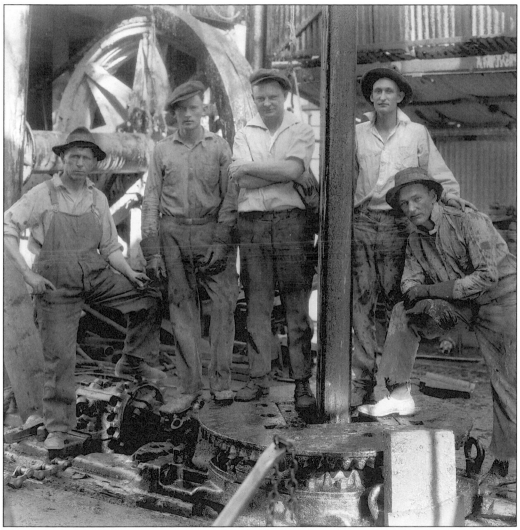

This crew poses for a picture at one of the Vedder Oil derricks in 1926. Taken in the Mount Poso Oil Field, the image shows the variety of characters who worked on a rig. By the looks of most of them, it has been a tough and grimy day.

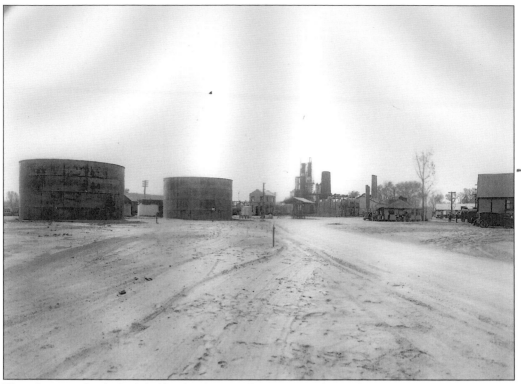

This photograph of a Richfield Oil refinery, taken in 1926, shows the simplicity of the operation as it was then, contrasted against today's high-tech approach. One thing has always stayed the same, though; the oil must be retrieved from the ground.

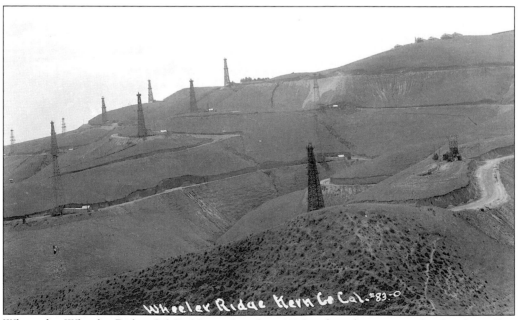

When the Wheeler Ridge Oil Field was found in 1923, oil exploration in the Southern San Joaquin Valley expanded. Pictured here is part of the field on the hillside.

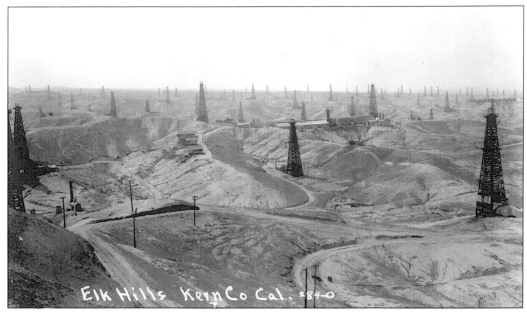

Elk Hills Kern Co Cal. #84-0

The Elk Hills Naval Reserve Oil Field, on Kern County's West Side, opened in 1912, creating a vast reserve of oil for the United States. In the 1930s, it was full of derricks, standing like a forest in a desert.

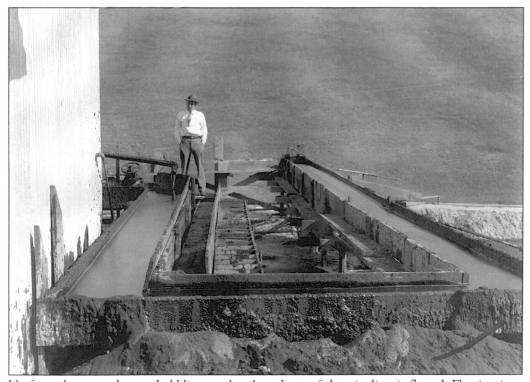

Up from the ground came bubbling crude oil, and out of the pipeline it flowed. Flowing into the trough from the outlet pipe at this 1926 Vedder Oil Company site, this oil came from the Round Mountain Oil Field north of Bakersfield.

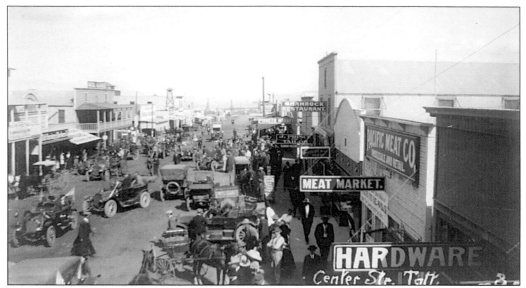

Taft was originally a siding for the Sunset-Western Railroad, on the west side of Kern County. Since its post office was opened on April 22, 1909, it has always been a thriving oil community, located at the southern end of the San Joaquin Valley oil production area. Originally called Siding Number 3, followed by Kerto, Moro, and then Moron, the community was renamed Taft in 1908, in honor of President William Howard Taft. As seen in this photograph from the 1920s, Center Street was the bustling, main thoroughfare that filled the area with commerce and activity.

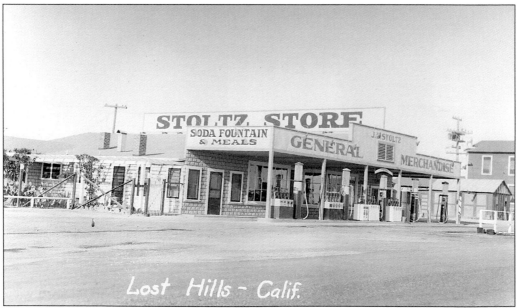

Lost Hills, in northwest Kern County, began in 1910, following the discovery of oil in the Lost Hills Oil Field. The post office was originally established in 1911 as Cuttens, though the name was changed in 1913. Oil kept the community going for years, but it is now a very strong agricultural area, with the delivery of water to the West Side. The Stoltz Store, pictured here in the 1920s, stood for many years, serving the surrounding area.

48

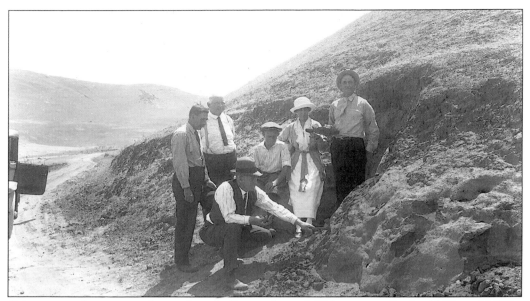

Oil came on the scene in the southern valley in the mid-19th century. By the 1850s and 1860s, both the West Side and near the Kern River had discovered oil seeps in the area. The first refinery in the southern valley was the Buena Vista Refinery, which operated on the West Side from 1864 through 1867. However, little interest was generated to continue the operation because the widespread use of oil did not exist. Suspicions of the presence of oil were correct, and 1877 brought the first drilled oil wells in the McKittrick area. This group, shown above in the 1920s, investigates the paleontology of the land around McKittrick, where the famous McKittrick Tar Pit is located.

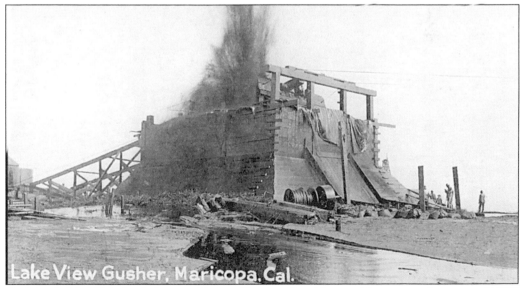

Lake View Gusher, Maricopa, Cal.

On March 14, 1910, the Lakeview Gusher Number One blew and began spewing up to 48,000 barrels of crude oil per day. It flowed for over 18 months, producing an estimated nine million barrels of oil. The Lakeview Gusher is 1.5 miles north of Maricopa off of State Highway 33. This 1910 photograph shows the gusher still shooting into the air, and in the middle of the wreckage, its destroyed derrick can be seen.

49

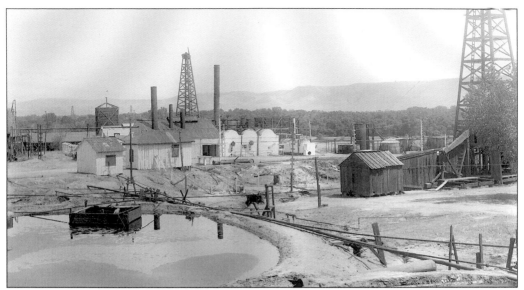

Superior Oil Company had numerous facilities in Kern County. This one is located in the Kern River Field, north of the Panorama bluffs, which can be seen in the background. Behind the refinery are trees from the Kern River basin, which runs along the Kern River Field. This 1925 photograph shows the settling ponds and part of the workings of a small refinery.

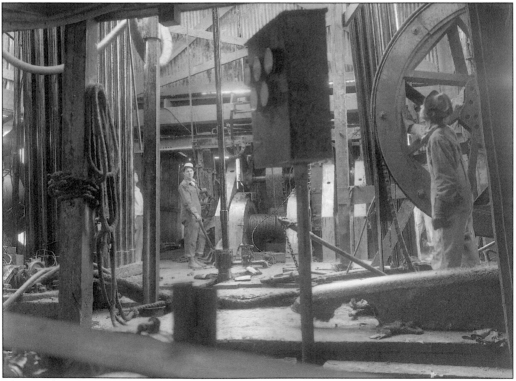

This it what the inner workings of a 1920s oil derrick looked like. The casing is being lowered into the well in sections, each one pieced together as it is lowered. Note the massive equipment used in this Richfield Oil operation during 1926.

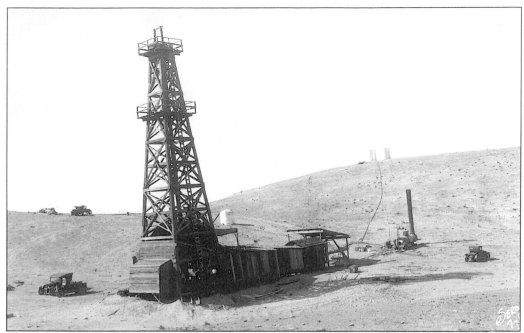

This oil derrick, as it appeared in 1924, is a wooden structure, with the belt housing running off to the right. It looks like the boiler is down. In the right side of the picture, it can be seen being fixed. Note the pipe running up the hill to the storage tanks.

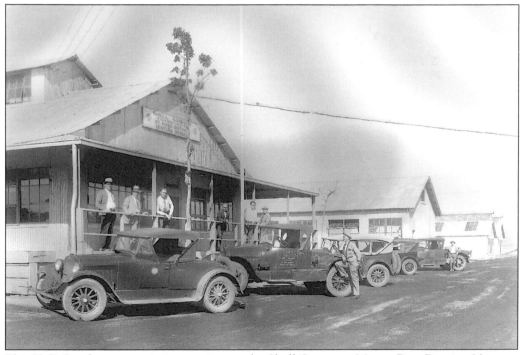

This H.C. Smith crew awaits instructions at the Shell Company Mount Poso District, Ventura Division office, located north of Bakersfield. Taken in the mid-1920s, it shows a typical oil field scene.

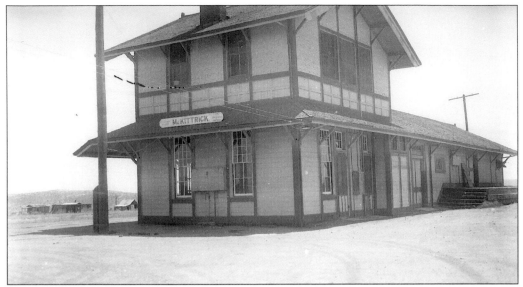

The McKittrick Depot was built for the Southern Pacific Railroad to handle passengers and freight for its West Side line, but it served passenger traffic for only a brief period of time. McKittrick was founded in the early 1890s and was originally called Asphalto, named after the huge asphaltum deposits in the area. Another early name for the community was La Brea. Its post office was established in 1893 as Asphalto and changed to McKittrick in 1900. This photograph was taken in the early 1930s.

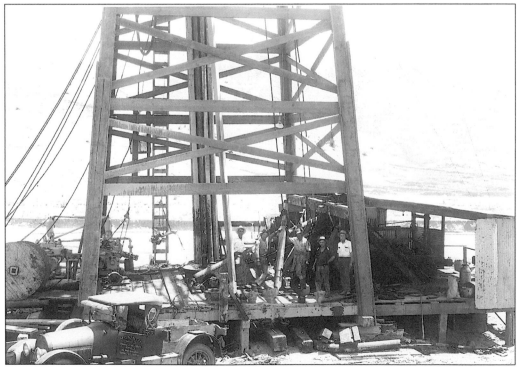

The H.C. Smith Company specialized in oil well coring and reaming. The crew here is at work on a Richfield Oil well, in the Round Mountain field during the mid-1920s.

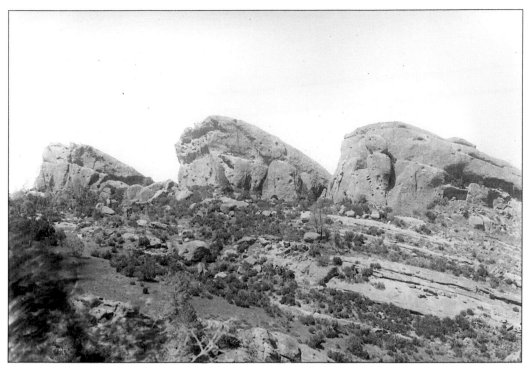

Joaquin Murrieta, or "El Famoso" as he was called, made the location known as Las Tres Piedres famous as a bandit hangout. Murrieta was a notorious bandit of the 1850s in California. A lover of horses, he was responsible for several drives into Mexico after rounding up herds in California. These were, of course, stolen from local ranches. It is said that Murrieta and many of his gang were killed in a fight at the nearby Cantua, by a posse led by Harry Love. However, others say he escaped.

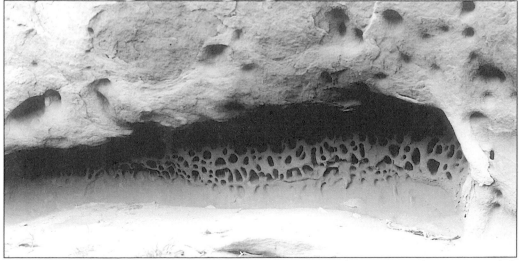

This is Post Office Rock, a geologic formation at Las Tres Piedres. Notes and money were left here for others to pick up later. One story says that Joaquin Valenzuela, who ran with Murrieta, left 30 pieces of silver in a pigeonhole for his hostler Avalino Martinez.

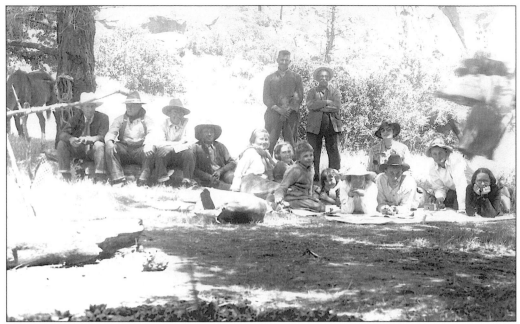

Looking like a picnic, this picture shows the group formed by historian Frank F. Latta in 1935 to explore the Las Tres Piedras area for clues about Joaquin Murrieta. Latta is the tall man standing at the rear, next to Adolph Domengine Sr. The Latta family is scattered throughout the picture, along with many people who were related to the Murrieta horse gangs.

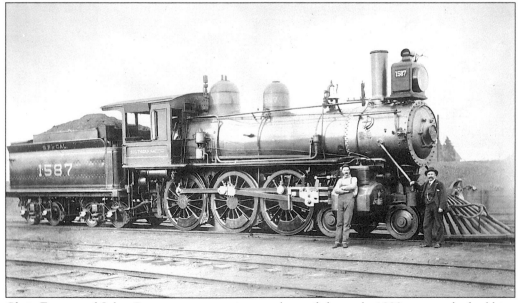

Chris Evans and John Sontag were notorious outlaws of the early 1890s, accused of robbing several trains between Delano and Ceres on the Southern Pacific line. They were also accused of the same crime in Minnesota, and by some accounts, they were known as cold-blooded killers. Sontag and Evans were finally captured in 1893 at Stone Corral, in Tulare County. This early photograph, taken in the 1890s, shows one of the engines they held up, an old link and pin engine.

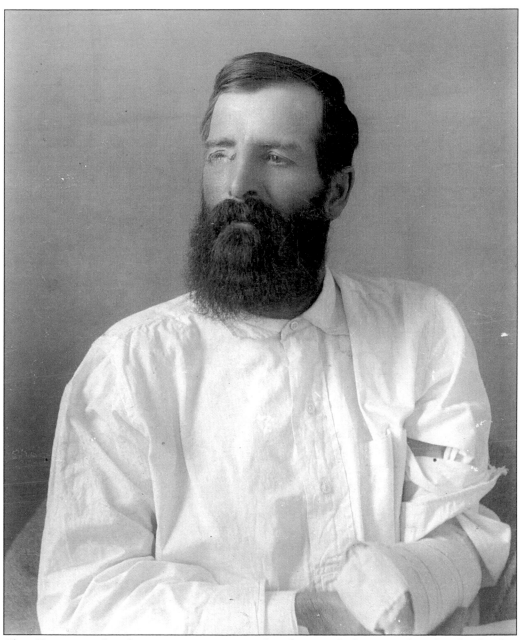

Chris Evans was a handsome man, as is seen in this photograph that was taken shortly after his capture at Stone Corral in 1893. Evans lost an eye and part of his left arm during the battle. Stone Corral is located northeast of Visalia, in the foothills of Tulare County.

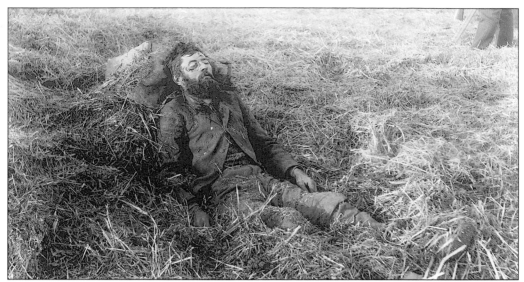

In this grisly photograph, John Sontag is wounded and lying in a straw and manure pile after the 1893 battle of Stone Corral. He and Chris Evans were finally tracked down and captured by a four-man posse comprised of U.S. Marshal George E. Gard, Fresno County Deputy Sheriffs Hi Rapelji and Fred Jackson, and Los Angeles Detective Tom Burns, who was working for the Harry Morse Agency. Sontag was taken to the hospital where he later died. Evans was tried for murder and sent to prison. The pair was never tried for the train robberies.

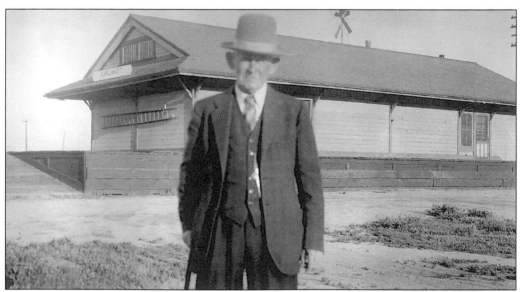

Littleton Dalton was the last of the Dalton brothers. They terrorized both the mid-west and part of the Southern San Joaquin Valley in the early 1890s. Littleton Dalton was not a Dalton Gang member, but he did shelter and comfort his brothers when they needed it. Pictured in 1937, Dalton is standing near the Earlimart Railroad Station, earlier known as Alila. Founded in 1895, its post office operated sporadically until 1899. It was reestablished as Earlimart in 1907, named after the town of Early Market a half mile south. The name was later shortened to Earlimart. After Bob and Emmett Dalton boarded the train here in January of 1891, they robbed it and escaped.

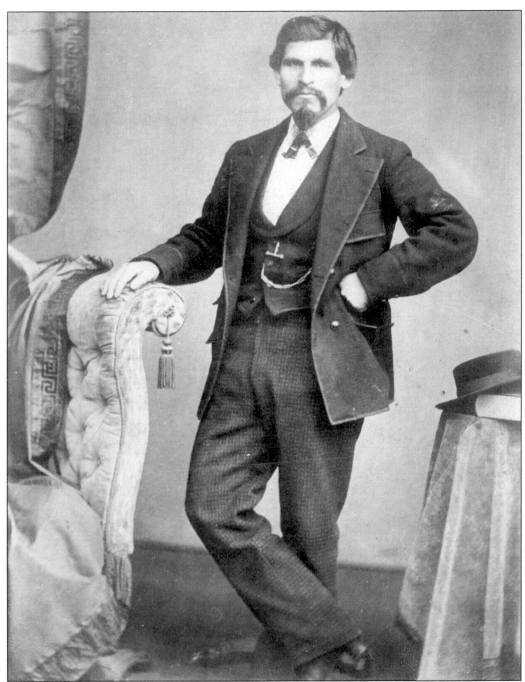

Tiburcio Vasquez was another well-known, notorious bandit from the mid-1850s through the mid-1870s. He frequented the Southern San Joaquin Valley and was said to have raided several communities, including Firebaugh's Ferry, Kingston, and Tres Pinos. Tiburcio was a handsome and well-educated man who was born in Monterey in 1835. His home is still located behind Colton Hall. Like Joaquin Murrieta, Vasquez made his main hideout at the Cantua in southern Fresno County. Vasquez was captured in Los Angeles County in 1875. He was taken to Santa Clara for trial and was eventually hanged.

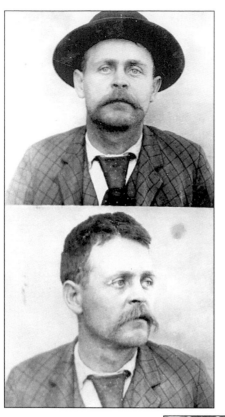

James McKinney was known as a pretty nice guy, until he started imbibing. Born in Colorado, McKinney moved with his family to California around 1880, eventually settling in Porterville. Soon he was in trouble with the law. This photograph was probably taken at San Quentin in the 1890s. Jim McKinney was infamous for his 1901 killing spree in California and Arizona. His days as a desperado came to a brutal end when he died during a gunfight at the famous Chinese Joss House in Bakersfield.

The Joss House in Bakersfield was a meeting place for one of the Chinese Associations. It was known as a rooming house and became widely known for its gambling and other activities of the evening. This photograph was taken immediately after the ignoble "Battle of the Joss House." In this ill-fated clash in 1903, McKinney was killed in a fatal shootout. Deputy Sheriff Will Tibbett and Bakersfield City Marshall Jeff Packard were also mortally wounded during the blazing gunfight.

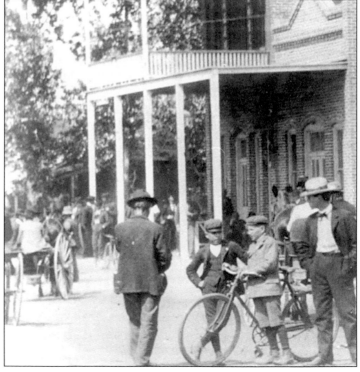

Four

CROSSROADS OF THE SOUTHERN SAN JOAQUIN

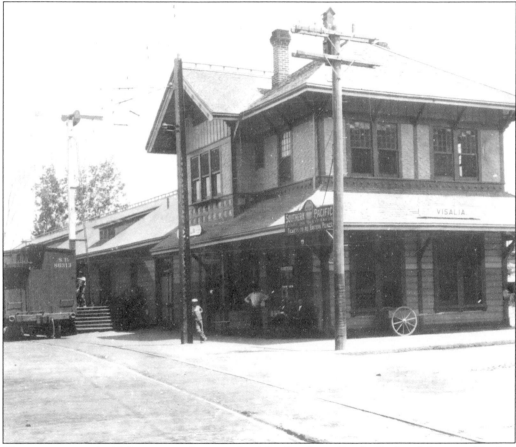

This is a great early-20th-century photograph of the Southern Pacific Railroad depot in Visalia. It served the east-west line that originally ran from Visalia to Goshen, which was later extended to a point past Coalinga. This wonderful two-story building served Visalia well into the second half of the 20th century, when it was demolished. The overhead lines were for the Visalia Electric Railroad engines that ran from Visalia through Exeter, into the east side of the San Joaquin Valley.

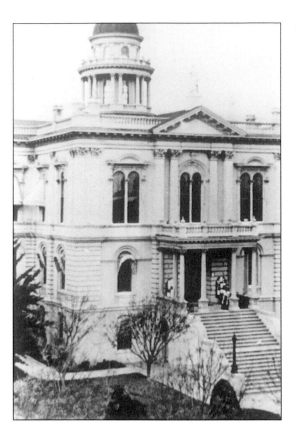

The steps of the old Tulare County Courthouse, in Visalia, have been gone a long time, but the memory of this majestic edifice will linger on always.

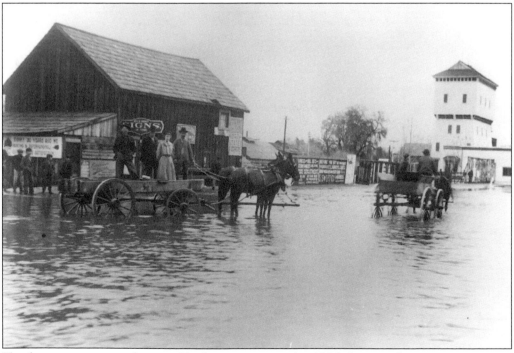

Floods were a constant threat in Visalia, as is seen in this 1906 photograph.

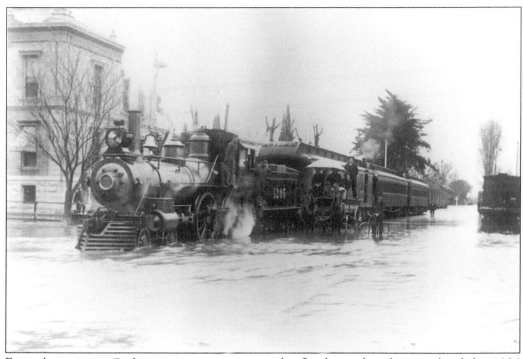

Even the train to Goshen was not immune to the floods, as this photograph of the 1906 flood attests.

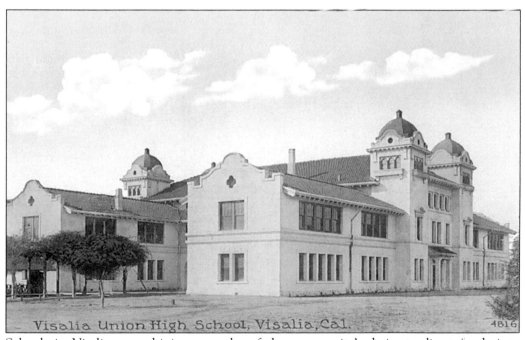

Visalia Union High School, Visalia, Cal. 4816

Schools in Visalia were shining examples of the community's desire to direct funds into education. This photograph shows the Visalia Union High School, c. 1915.

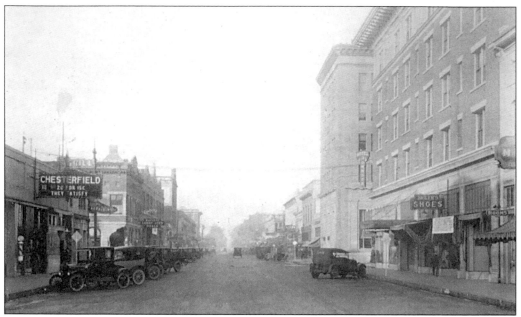

This is Visalia's Main Street as seen around 1930. The Hotel Johnson is the large building visible on the right.

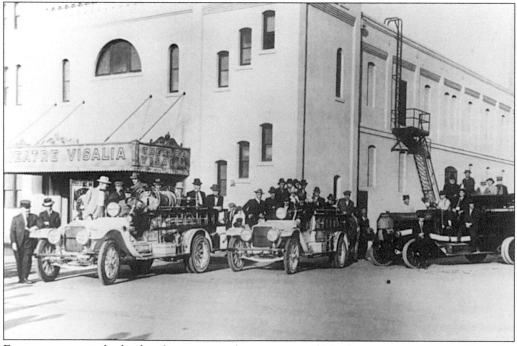

Every community had a fire department of some sort, and Visalia was no exception. Here is a gathering of the Visalia Fire Department in front of the old Theater Visalia.

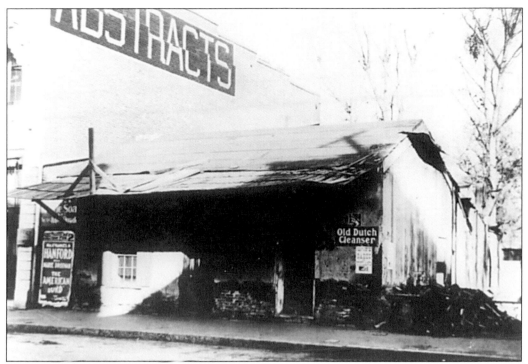

Of course, the fire department is not always able to save the day, as indicated by this photograph of one of Visalia's early buildings after a fire.

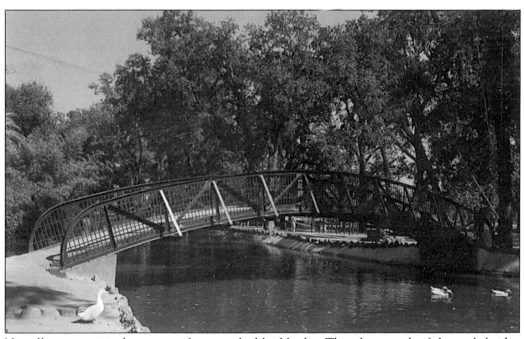

Not all communities have magnificent parks like Visalia. This photograph of the arch bridge over one of Mooney Grove's waterways was taken in the early 1950s.

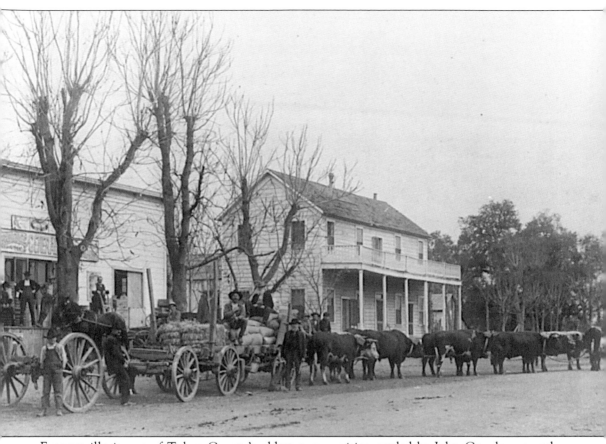

Farmersville is one of Tulare County's oldest communities, settled by John Crowley around 1860. This photo of the Brundage Store and Brown's Hotel was taken in 1898. The post office in Farmersville was first established on August 26, 1868.

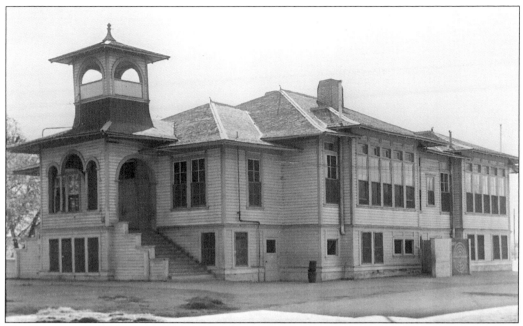

The Farmersville Elementary School was the pride and joy of Farmersville. The school was later named Snowden School for George L. Snowden, an early educator in Farmersville. It was a substantial two-story building, and it served the community for generations well into the mid-20th century.

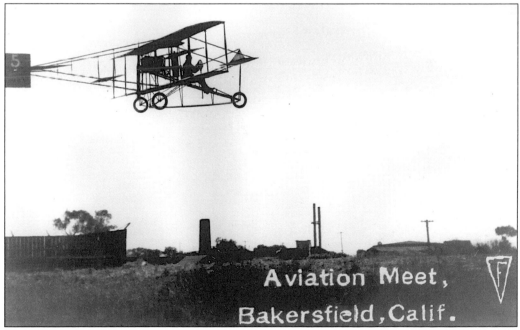

Aviation Meet,
Bakersfield, Calif.

Kern County is known to be at the forefront of aviation history. The first Aviation Meet in the southern valley was held at the old fairgrounds near the public services building on Golden State Avenue. This Wright Flyer is seen skimming above the ground, with what little settlement that existed in the background.

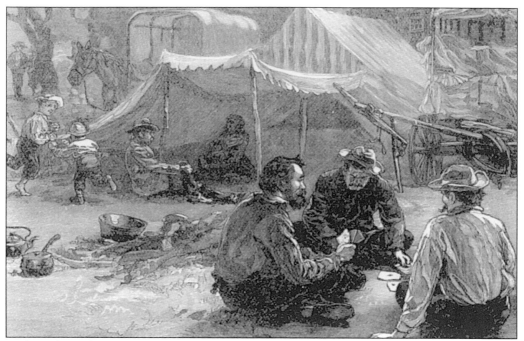

Back in the early days of Bakersfield, the town was known to be pretty rough and tumble. With the arrival of the Southern Pacific Railroad in 1874, more new people came to the area, including settlers for the outlying lands. Bakersfield was located on the road between northern and southern California, so a great deal of wagon traffic passed through. The area that is now incorrectly called Olde Westchester was a swampy, forested area through which Panama Slough ran. It was known as a campsite for travelers, including the gypsies in this etching by W.P. Snyder. It was said in Bakersfield that mothers should always gather up their children lest the gypsies take them.

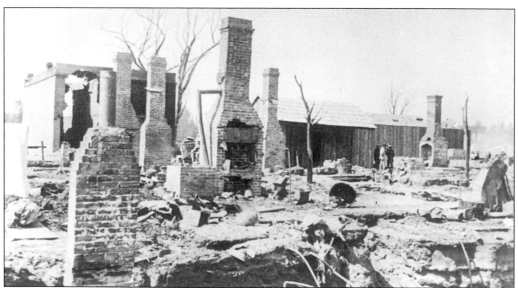

Like many early communities, Bakersfield had its ups and downs. Bakersfield's post office was established on August 28, 1868. Here are the remains of Chinatown after the great fire of 1889 wiped out virtually the entire business section of town.

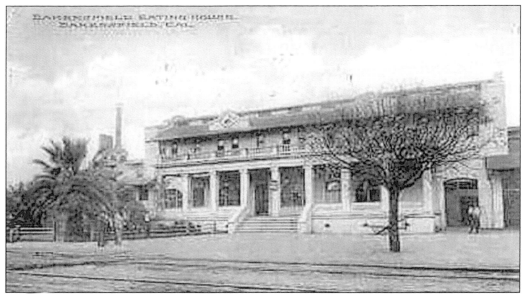

The Harvey House was one of Bakersfield's favorite dining places, located adjacent to the Santa Fe Depot at F Street. This early photograph of the Harvey House shows its grand architecture.

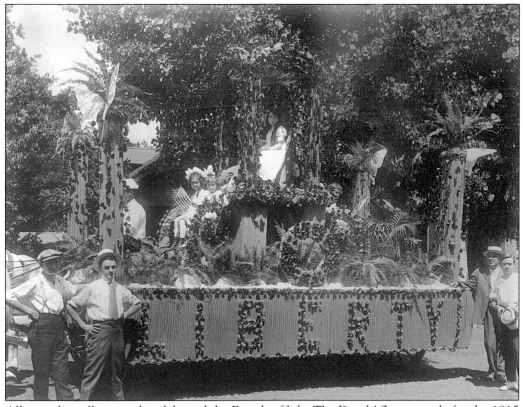

All over the valley, people celebrated the Fourth of July. The Druids' float is ready for the 1915 parade in Ba*kersfield, with youthful Marie Roux Hardwick and Eleanor Johnson Wells waiting to go.

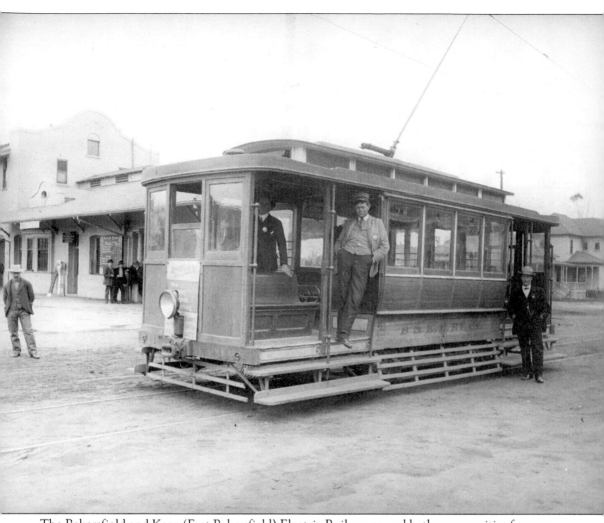

The Bakersfield and Kern (East Bakersfield) Electric Railway served both communities for over half a century. Here, one of the cars is stopped in front of the Santa Fe Depot at F Street. Note the Redlick's advertising on the front.

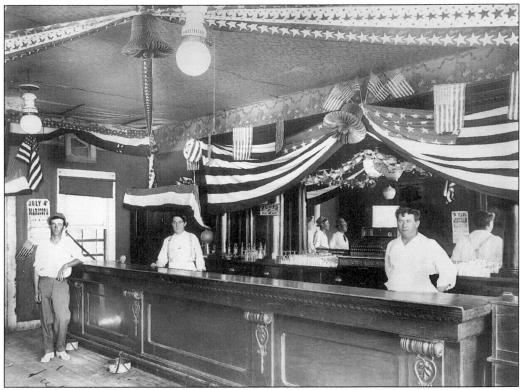

Entertainment for the gentlemen was an integral part of life in the oil community of Bakersfield. The Tropical Bar on 19th Street was one of the many bars and saloons in town. This 1915 Fourth of July photograph shows the bar decked out in American flags and bunting.

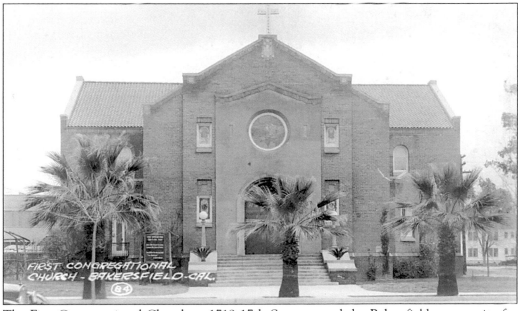

The First Congregational Church at 1719 17th Street served the Bakersfield community for many years. This is an early photograph of the building, taken around 1915.

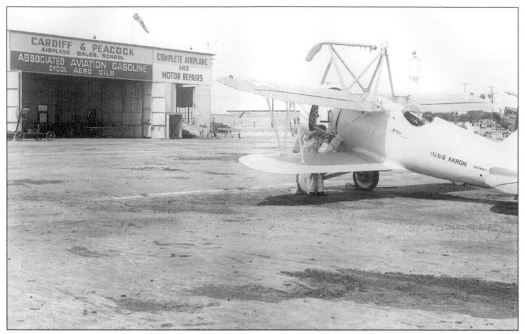

Kern County and Bakersfield have been at the forefront of aviation's history since its beginning. Here is a picture of one of the USS *Akron's* biplanes being serviced at the Cardiff and Peacock hanger at Kern County Airport in the mid-1930s. The *Akron* was a dirigible and flew over the valley on one of its public relations tours.

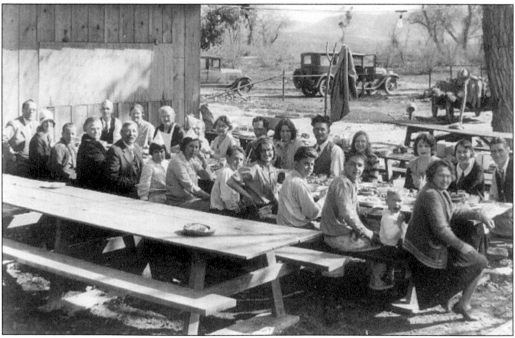

Picnics were important to families, friends, and businesses. This family picnic was held out at the old Shell Picnic Grounds, across from Hart Park, near Bakersfield. The Rogers, Stiern, and Boultinghouse families enjoyed the day's outing.

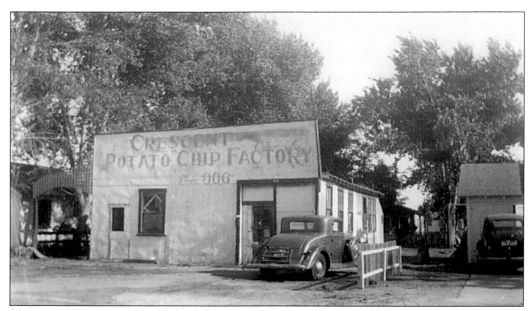

The Crescent Potato Chip Factory is one of those obscure businesses that came and went without much ado. It is pictured here, in all its glory, at 615 33rd Street in the late 1930s. At this point, the business had changed its name to the Bakersfield Potato Chip Company and was operated by Maurice LeCourant and Jack Daugherty. It was later sold to H.P. Willsley, who moved it to 1019 30th Street, where it faded into obscurity during World War II.

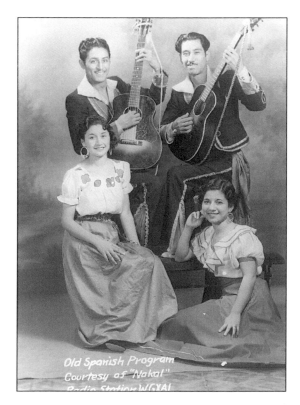

In the early days of radio, a number of vocal groups entertained the limited audience of people who possessed radios. These entertainers were featured on the Spanish program heard on W6XAI, Kern County's early radio station.

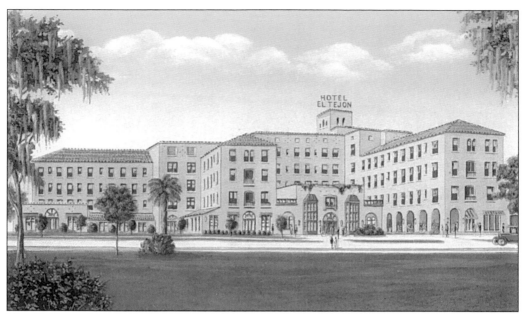

The El Tejon Hotel was Bakersfield's largest, taking up most of two city blocks. It was the meeting place of choice for many groups and organizations, therefore many conventions were held there. In the late 1960s, it was demolished and replaced by the Bank of America building.

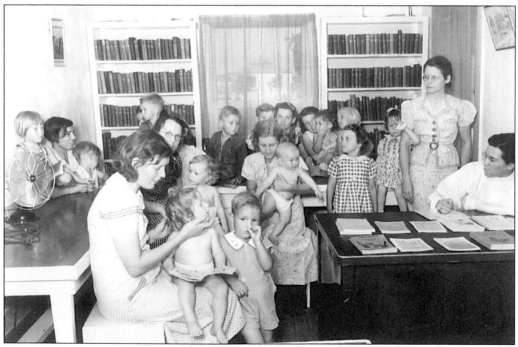

This 1938 photograph shows a group of mothers in a federal migrant camp at a well-baby conference coordinated by the Kern County Health Department. Many of these programs were put in place to deal with the problems associated with the upheaval of the Dust Bowl migration into California.

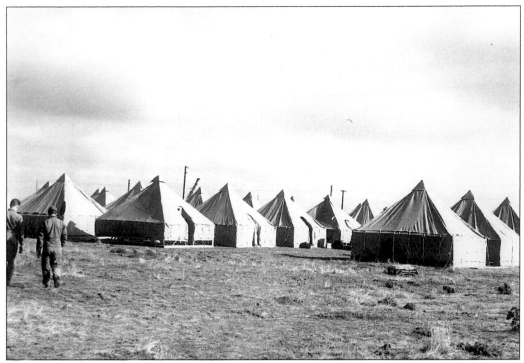

The Kern County Airport has been a training base for pilots for a number of countries, including our own. This remarkable photograph, taken in 1941 at the airport just before the start of World War II, shows the bivouac of pilots for their term during training.

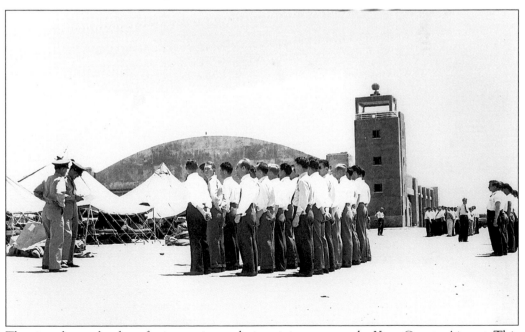

The air cadets gather here for inspection at their training camp at the Kern County Airport. This June 1941 photograph shows part of the squadron awaiting instructions from their commanding officer. Note the large hanger in the background; it is still standing at the airport.

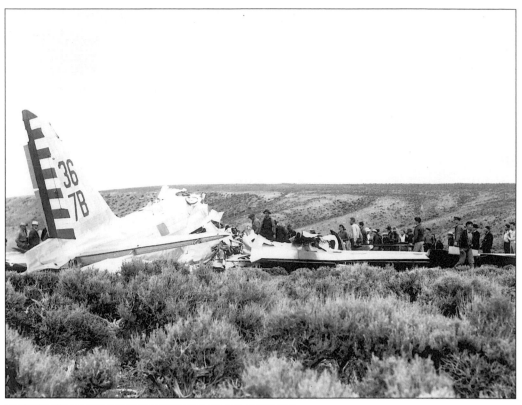

Every once in a while, accidents happen, as seen in this photograph of an army bomber crash near the Panorama Bluffs in June 1941. Kern County Airport launched thousands of flights during its time as a training base, and few accidents actually occurred.

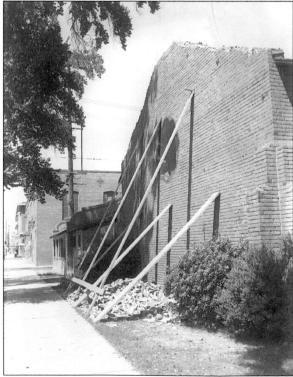

Many buildings had major damage after the July and August earthquakes rocked Kern County. St Paul's Church, on 17th and Eye Streets in Bakersfield, was no exception. The masonry sidewall is pictured here, propped so as to remain upright. The church was torn down soon afterward, and a new edifice was constructed further east on 17th Street.

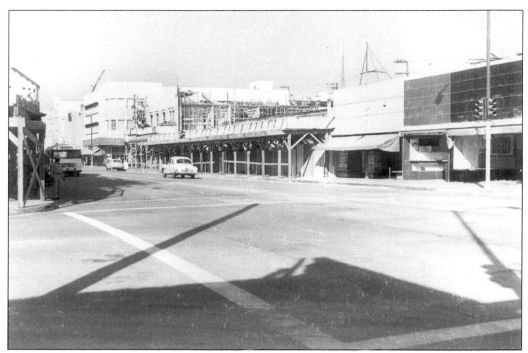

The earthquake also severely damaged the commercial area of Bakersfield. On the block of 19th Street between K and L Streets, several buildings lost their upper levels.

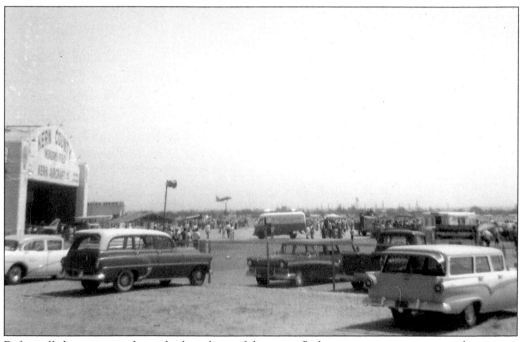

Before all the concern about the hijacking of domestic flights, many airports were wide open to visitors. Bakersfield's Meadows Field was no exception. In this photograph of the 1957 Airshow, note the jet doing a low, slow speed pass above the runway. The airshows in Bakersfield were popular events, held for many years after World War II.

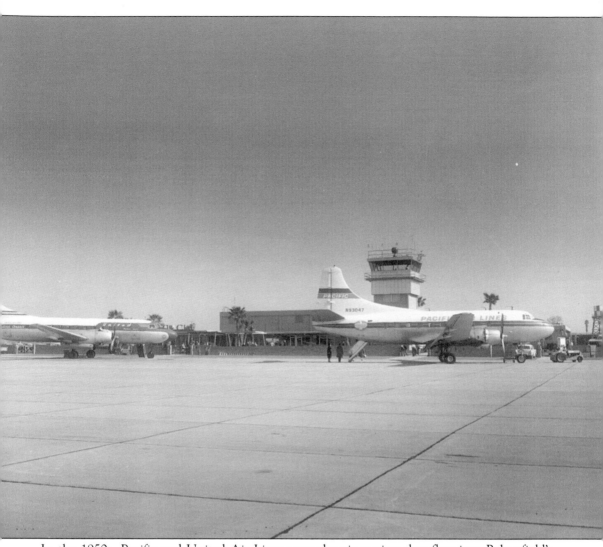

In the 1950s, Pacific and United Air Lines were the air carriers that flew into Bakersfield's Meadows Field. Here, both carriers sit in front of the terminal and old tower, ready to load passengers.

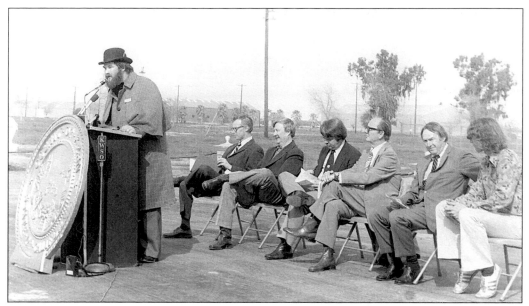

The flight of the Gossamer Condor at Shafter Airport was a significant event in the history of flight. Paul MacCready designed an aircraft to meet the challenge of the £50,000 Kremer International Competition, which required a completely man-powered flight to fly a figure eight around two markers spaced one-half mile apart. This is a photograph of the dedication of California State Historic Landmark Number 923. It was the beginning of a long line of crafts, including the cross-channel Gossamer Albatross, Solar Challenger, and the Centurian. Pictured here, from left to right, are designer Paul MacCready, director of Kern County Airports Steve Schmitt, county supervisor Gene Tackett, Kern County museum director Richard C. Bailey, California State Historic Preservation officer Dr. Knox Mellon, and Gossamer Condor pilot Bryan Allen. Author Chris Brewer speaks. Christopher Reeve, who played *Superman*, was present, but is not seen in the photograph.

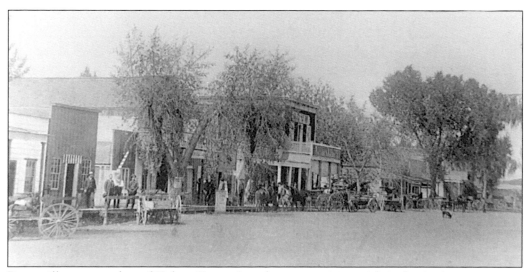

Porterville was another of Tulare County's early communities, with its beginnings as a stage stop. Porterville's post office was established on February 13, 1871. This 1880s photograph shows Main Street between Mill and Oak Streets.

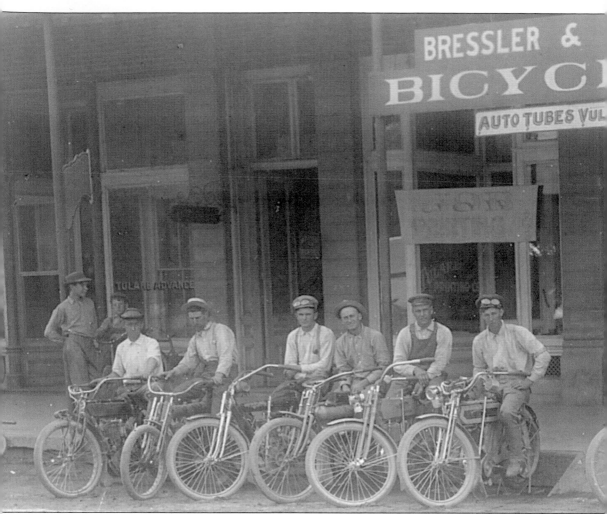

Bressler and Lightner's Bicycle Shop was an important business in Tulare, especially for the youth of the community. It was also an important shop for the motorcycle enthusiast, as

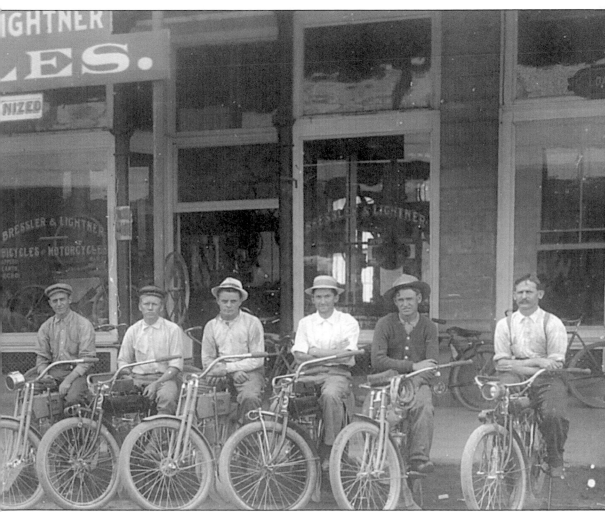

indicated by the line-up of Harley Davidsons and Indian motorcycle riders awaiting the word to take off. To the left is the *Tulare Advance* newspaper office.

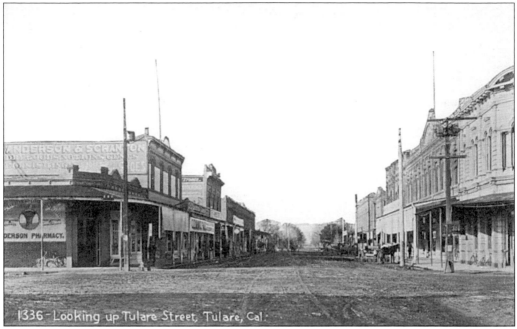

Looking up Tulare Street in 1910, one can see Anderson's Pharmacy on the left and a dirt-clad street. Tulare was a bustling city with dirt streets and multiple-story masonry buildings.

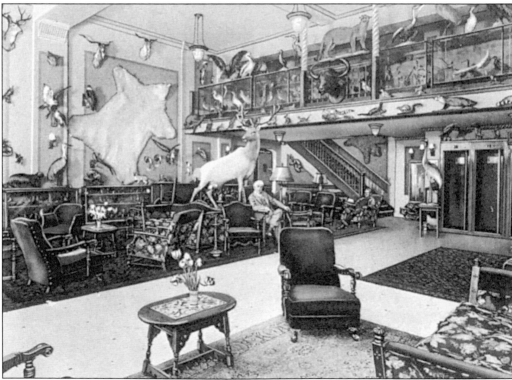

The Hotel Tulare was the city's showplace for many years. At one time, its lobby was full of hunting trophies. The hotel burned in the 1980s, destroying one of Tulare's finest landmarks.

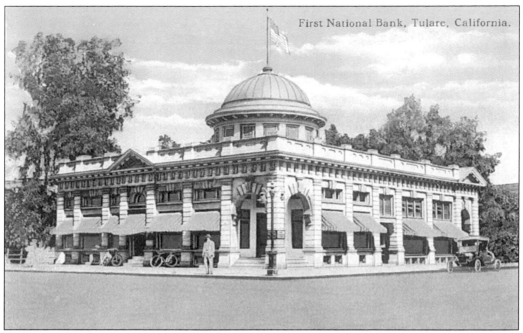

First National Bank, Tulare, California.

Tulare's First National Bank was indeed a landmark in the city. Taken around 1915, this photograph shows the building and its spectacular architecture, dome and all.

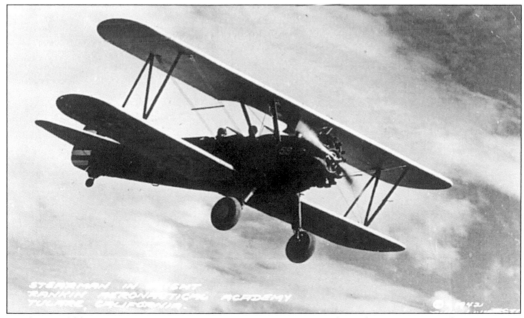

Rankin Field became an important Army Air Corps training base during WWII. The Stearman was the plane of choice, used extensively for early training operations. This photograph from 1942 shows a Rankin Aeronautical Academy pilot and trainer in flight.

The Kern County Health Department operated numerous programs to assist the migrants coming in from the Dust Bowl in the 1930s. The Kern County Superintendent of Schools operated a number of migrant schools. This one was located at Panama, south of Bakersfield.

Greenfield is also an early community of Kern County, located south of Bakersfield. It was first settled back in the late 1860s and later became one of the Kern County Land Company's colonies. This photograph was taken about 1920 and shows the Wellman and White family ranches located at Kearno Road and Union Avenue.

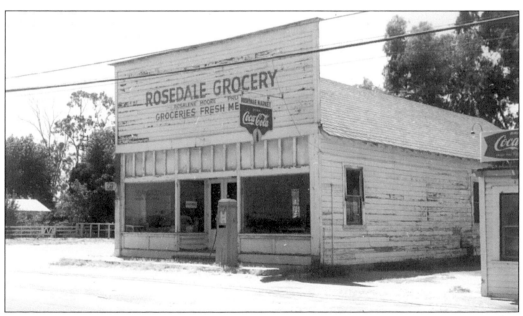

Rosedale was another of the Kern County Land Company's colonies from 1890. Its post office was established on January 7, 1891, and closed in 1913. Although the colony was essentially a failure, the colonists generally stayed on. Rosalene Moore was the proprietor of the Rosedale Store, pictured here. This photo was taken in the early 1970s, but the store's appearance had not changed for decades.

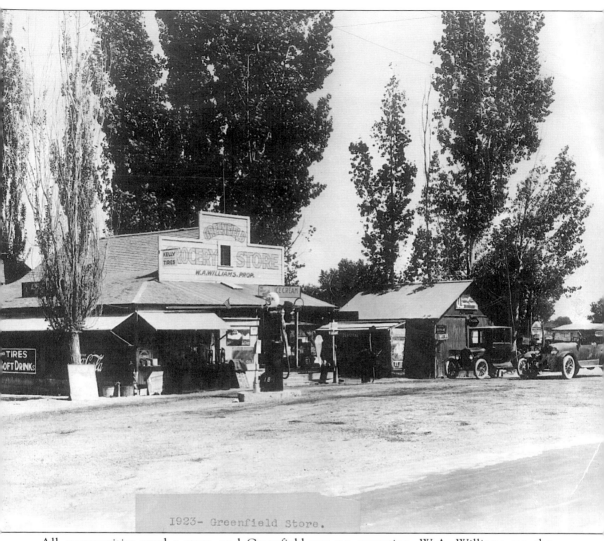

1923- Greenfield Store.

All communities need a store, and Greenfield was no exception. W.A. Williams ran the Greenfield Grocery Store on Union Avenue, south of Bakersfield. This 1923 photograph shows the store and its upright gasoline pump in front.

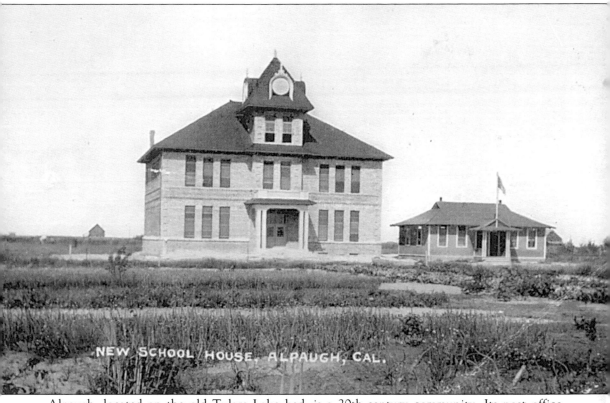

NEW SCHOOL HOUSE, ALPAUGH, CAL.

Alpaugh, located on the old Tulare Lake bed, is a 20th-century community. Its post office was established on February 16, 1906. As is evident in this 1914 photograph, the community has always cared for its children's education. Alpaugh's wonderful old school building appears on the right, with the new, multi-story building pictured at center. Note the flat land around the schoolhouse.

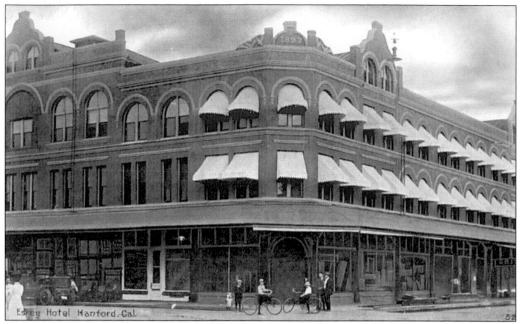

Hanford has always been a community with wonderful architecture. Its post office was opened on February 16, 1877. This photograph shows the new Esrey Hotel in its entire magnificent splendor. In this 1910 image, the corner saloon appears to be closed, with building material still leaning up against the windows. On the right is the hotel grill.

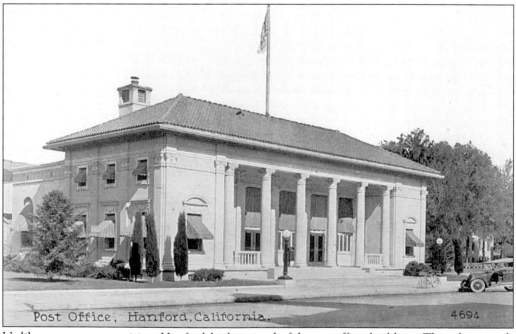

Unlike many communities, Hanford had a wonderful post office building. This photograph shows the then new Hanford Post Office c. 1920.

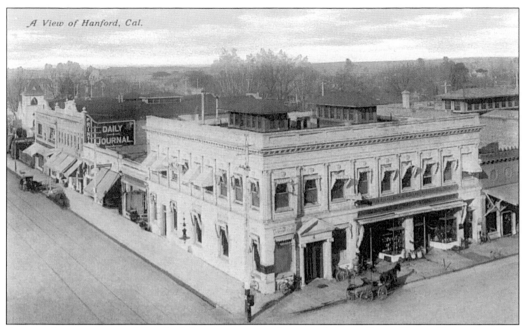

A typical street scene of Hanford shows wagon and automobile traffic on Douty Street.

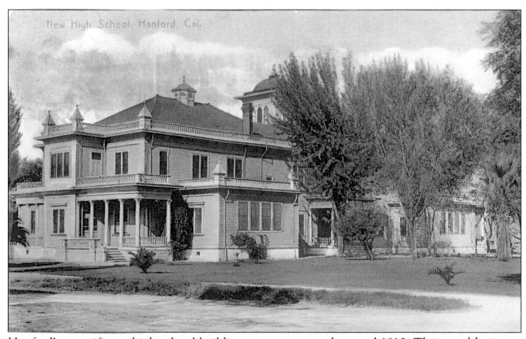

Hanford's magnificent high school building was constructed around 1910. This notable image shows the new school as it was then, with railing all the way around the roof.

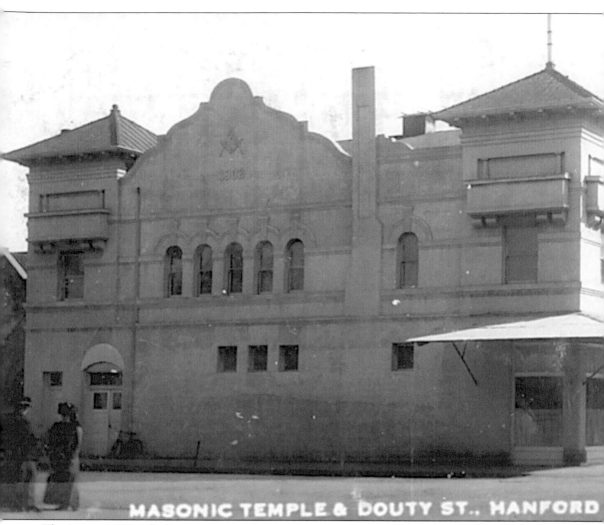

MASONIC TEMPLE & DOUTY ST., HANFORD

The Masonic Temple is an important landmark in any community as it was in Hanford. The Mission Revival building, pictured here, was constructed in 1902. This wonderful image also shows Douty Street, with the old firehouse and its bell tower on the left. The Western

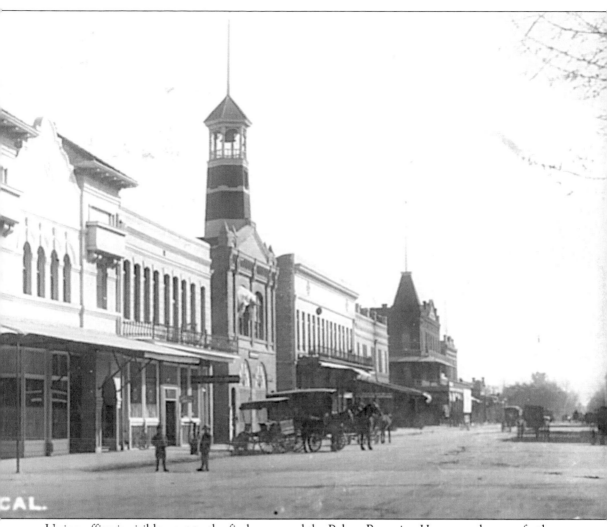

Union office is visible next to the firehouse, and the Palace Rooming House can be seen farther down the street.

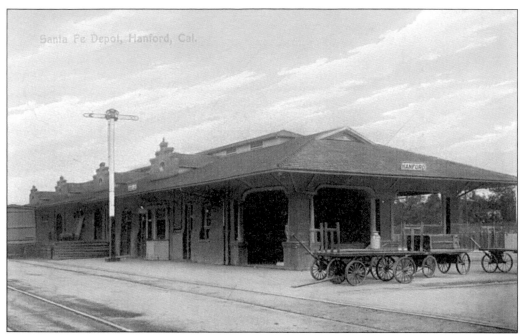

No community of any size is complete without a railroad. In this pre-1920 shot of the Hanford Santa Fe Depot, baggage carts await the next passenger train. Note the stepped dormer gables and the Hanford signs above the eaves.

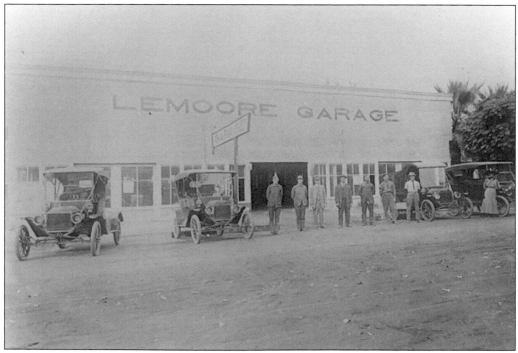

Lemoore is another Kings County community founded in the 1870s. Its post office was established on September 21, 1875. The Lemoore Garage was the local Ford Model T dealer, as is seen in this interesting image from 1913.

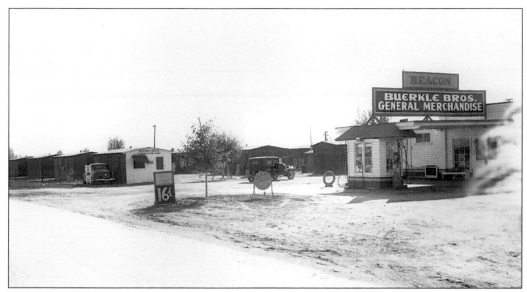

Buttonwillow was founded west of Bakersfield when the McKittrick Railroad branch line went through in 1895 and was named after a local Buttonwillow tree. Its post office was established on December 6, 1895. This 1937 image shows the Buerkle Brothers General Merchandise store and Beacon Oil dealership. The structures at the rear of the photograph are Buerkle's Pussywillow Camp, an early auto camp.

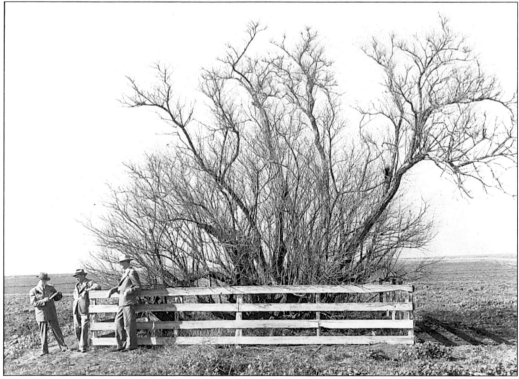

Now a California State historic landmark, this is the Buttonwillow Tree in 1942. Note that the field all around the tree is plowed and the tree completely fenced, to protect it from damage.

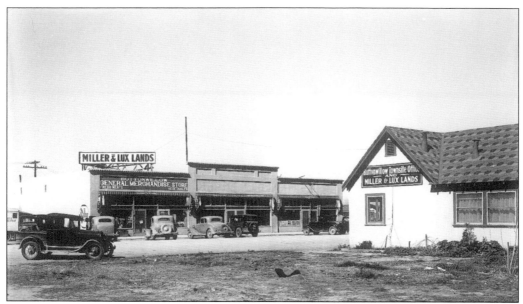

The Miller and Lux Lands office is pictured in this side view from February 1937. In 1885, Buttonwillow became the headquarters of Miller and Lux. The company had vast land holdings, and Buttonwillow became one of the areas to be sold off in the 1920s.

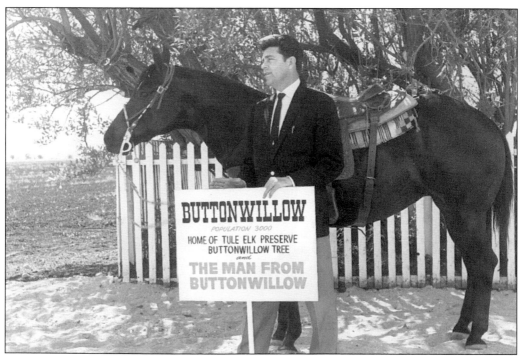

Actor Dale Robertson poses with his horse in front of the Buttonwillow Tree in a promotional photograph taken for the children's animated movie *The Man From Buttonwillow*. The movie was a story of the first undercover agent in America in 1869. The agent tried to prevent crooks from forcing legitimate settlers off of their lands, which sounds like a real San Joaquin Valley story. The movie featured the voices of Robertson, Edgar Buchanan, and Howard Keel.

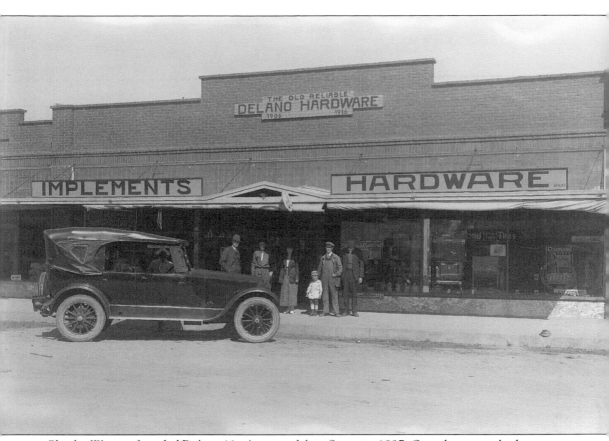

Charles Weaver founded Delano Hardware on Main Street in 1887. Over the years, the business changed owners and buildings, as is seen in this 1920s image.

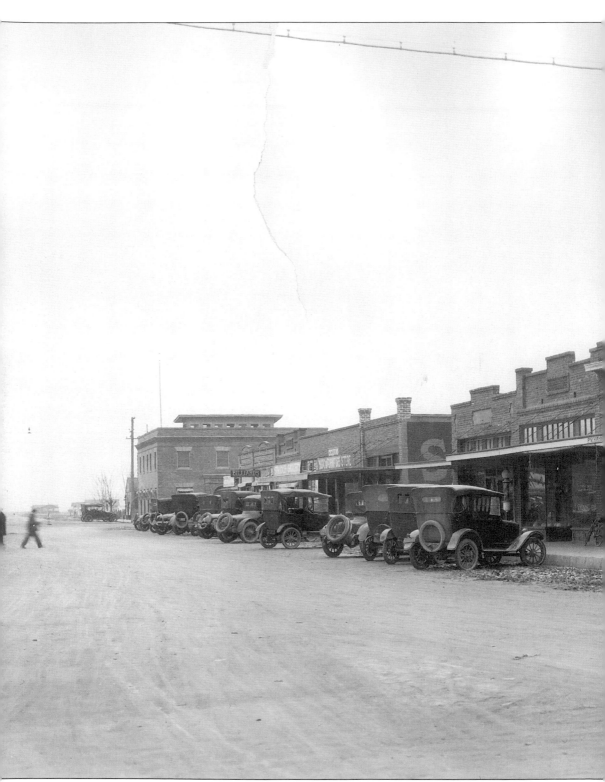

Delano's commercial district included the P.W. Hammer general merchandise store, visible here on

the right. Stradley Grocery and the Delano Music and Furniture Store are seen in the background.

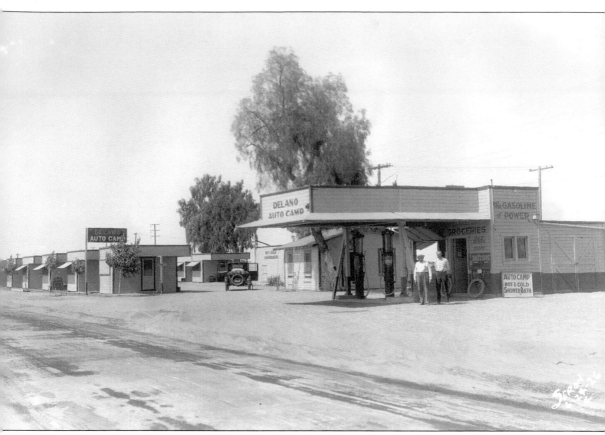

The Delano Auto Camp served travelers who passed through town. The grocery store behind the Richfield gas pumps served cold drinks and candy. This 1926 photograph shows the new-looking facility.

McFarland has always been a congenial small farming community in northern Kern County. Founded in 1908, with its post office opening on May 4th, it was named for James B. McFarland, who established the townsite along with W.F. Laird. Here, the Phillips Drug Store is visible on the left, with the bakery down the street. The streetscape looks similar even today.

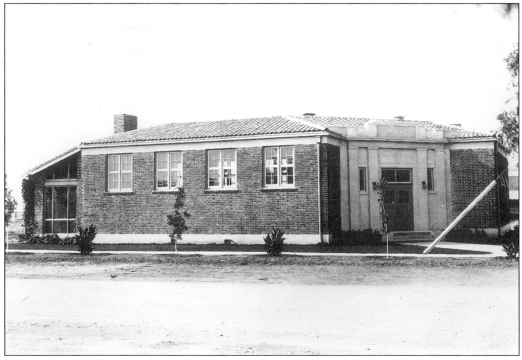

At one time, Kern County had one of the most progressive public library systems in the country. During the 1920s and 1930s, the library system expanded into the rural, outlying communities, like McFarland. Here is a late 1930s photograph of the McFarland branch of the Kern County Free Library system.

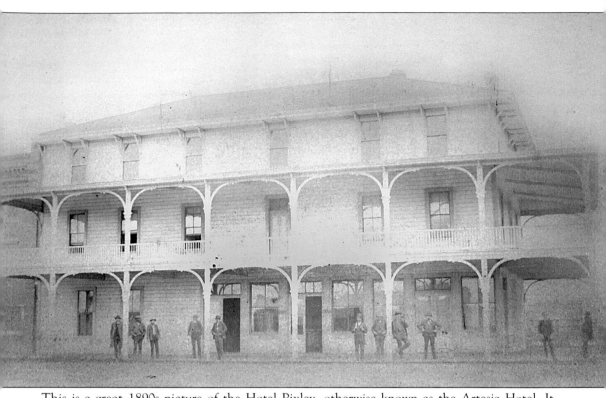

This is a great 1890s picture of the Hotel Pixley, otherwise known as the Artesia Hotel. It served many travelers passing through on both the stage and the railroad.

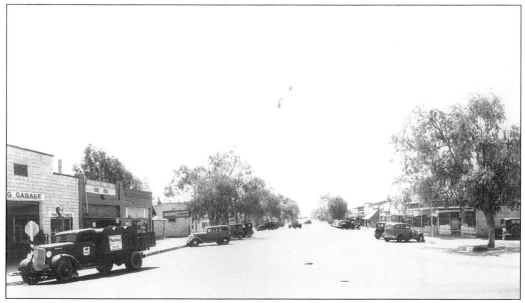

This late 1930s photograph shows McFarland on a hot summer's day. Kern Street was a wide thoroughfare, with numerous commercial buildings lining each side. Many wood-frame buildings housed everything from drug stores to rooming houses. This is an image of McFarland's past that is not seen too often. The tree-lined streets are typical of earlier times in the south valley.

Shafter started out as a late Kern County Land Company colony and soon was home to a large Mennonite colony. It had two sets of post offices. The first opened on October 31, 1898, and closed in 1905. The second opened in 1914. Here, the 1919 Santa Fe Depot is seen on its original site, across the tracks from the old King Lumber Company warehouse.

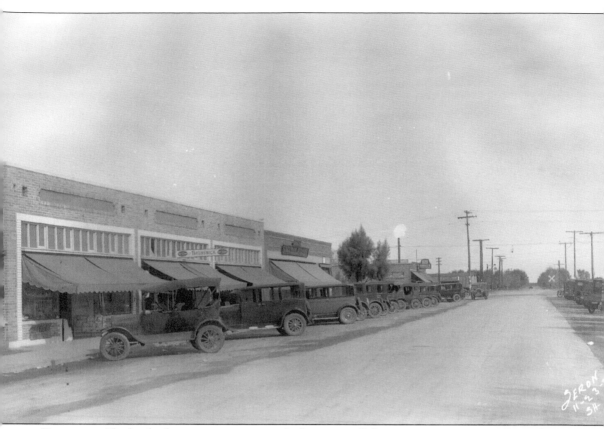

Downtown Shafter had an appearance typical of many small farming communities, with single-story store buildings. This 1926 photograph was taken looking down Central Avenue toward the railroad tracks. The Safeway store is in the middle of the photo.

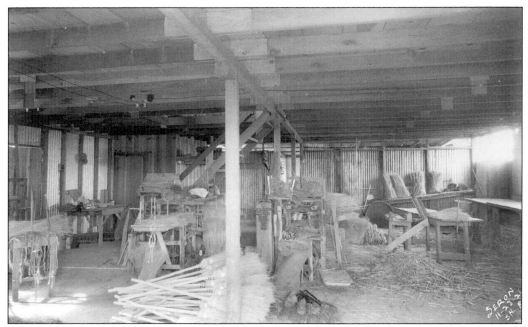

Many interesting industries were located in the small towns of the valley. This 1926 photograph of the broom factory at Shafter is complete with finished brooms in the middle of the photo. This factory was a small company that operated for a number of years, supplying brooms to businesses and households throughout the area.

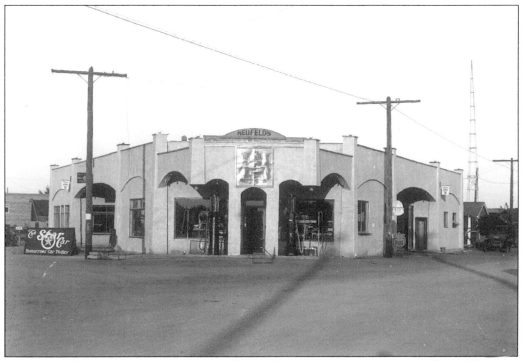

Henry Neufeld built this garage and Star Dealership to accommodate the local need for auto service. It still stands at the end of Central Avenue in Shafter.

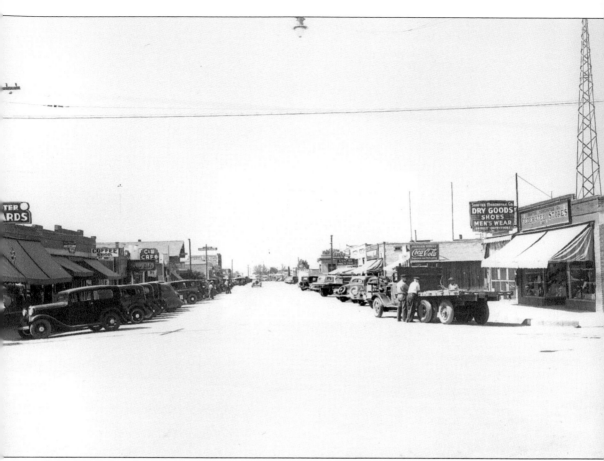

As seen in this photo from the mid-1930s, Central Avenue was a busy street. One can see the Shafter Mercantile Store on the right with Stringham's Drug Store visible further up the street.

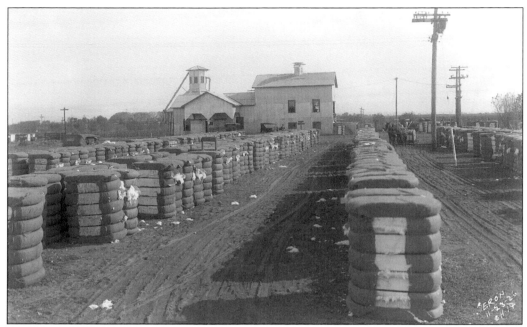

Cotton is an important crop in the Southern San Joaquin Valley. This 1926 photograph shows a Shafter cotton gin getting through its harvest, baling cotton as quickly as it is processed. Note the new bale arriving on the right via horse-drawn cart.

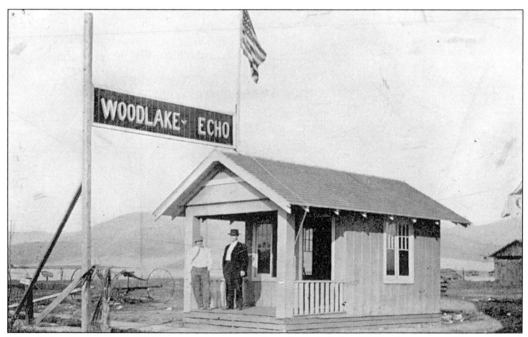

Woodlake is another 20th century community, founded in 1907. Its post office opened on January 30, 1908. Most every small community had a newspaper, and Tulare County's *Woodlake Echo* served the community for decades, bringing the news to local residents. This 1913 photograph shows the old *Echo* building on the east side of Valencia, about 100 yards north of Naranjo.

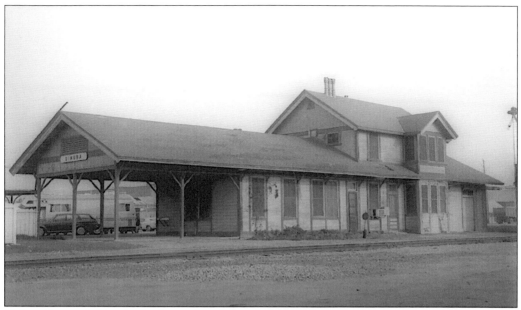

Tulare County's Dinuba had its railroad, too. It was, in fact, a railroad town, founded in 1888, when the Southern Pacific ran its east side line through the area. It was founded as Sibleyville, named after James Sibley, who owned the land on which it was situated. Incorporated in 1905, its post office opened on February 9, 1889. Here is a great photograph, taken in the mid-1970s, of Dinuba's Southern Pacific depot, with its long portico and two-story main building. The second story was used for the trainmaster's quarters.

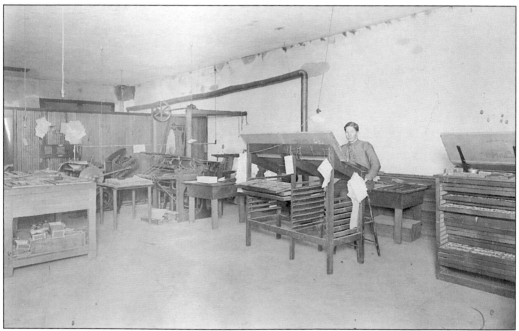

The *Woodlake Echo* was a busy place of business. In this 1914 photo, Sam Simpson sets up an issue of the *Echo* at the type case. After serving the community for more than 80 years, the *Echo* has ceased operations.

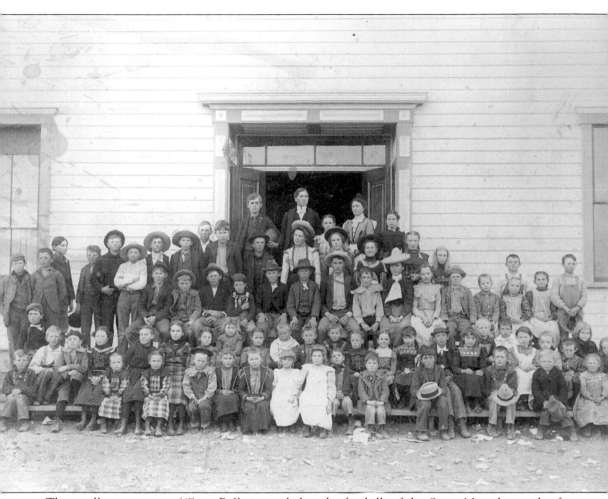

The small community of Terra Bella is nestled at the foothills of the Sierra Nevada, south of Porterville. Its history dates back to the 1890 McNear Warehouse, which opened to house locally grown grain. It briefly had a post office in 1891, which was later reopened in May 1909. The entire student body of the Terra Bella School is pictured here in 1905. The wood-framed building stood for many years, until it was finally replaced with a more modern facility. Note the garb of the students.

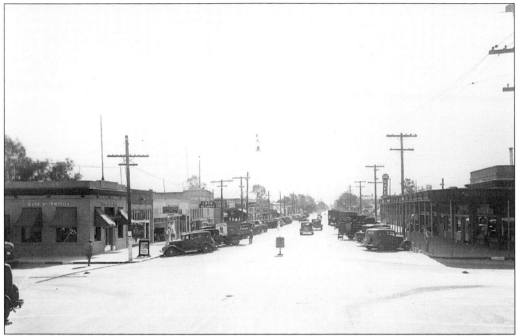

Wasco's Seventh Street became its main thoroughfare, after the town developed away from the railroad. Originally, Front Street was the town's main street. This 1935 photo of Seventh Street shows the Bank of America on the left and Neufeld's Auto Parts store on the right. A couple of drugstores and bars can be seen down the street.

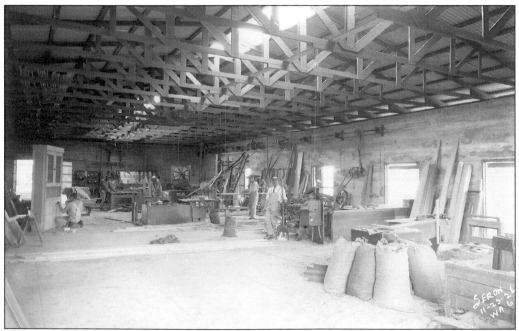

The Wasco Planing Mill was an important business in town. This 1926 photograph of the interior of the business shows the cabinetry work and vintage equipment. The fellow in the foreground is awaiting another pile of sawdust, so he can scoop it up and bag it.

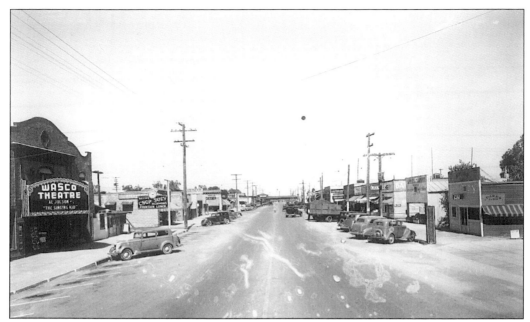

This is another great photograph of Wasco's Seventh Street, looking east toward the Santa Fe Depot, which is seen in the background. The Wasco Theater is playing *The Singing Kid*, with Al Jolsen. David Ellenwood's Chop Suey and the Pioneer Recreation Hall are visible farther down on the left, and the Spudin Cafe, Appley's Market, and the Brunswick appear on the right.

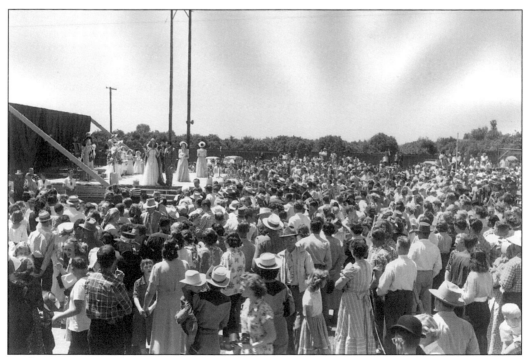

Lindsay's Orange Blossom Festival has been an important event in the Tulare County community for generations. This 1950 shot of the crowd listening to the festival queen is sure to evoke treasured memories of life in Lindsay.

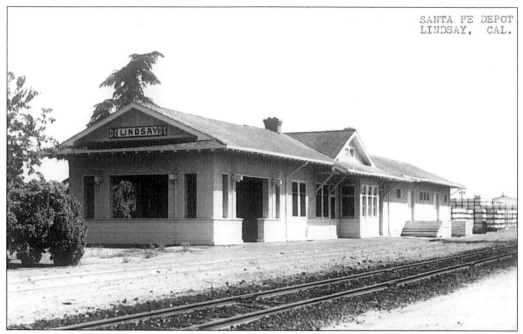

The Lindsay Santa Fe Depot was constructed as part of the Minkler and Southern Railroad after it had been established in 1914. It was a partially granitized building with a slate-like roof. These lost depots are a great reminder of the past.

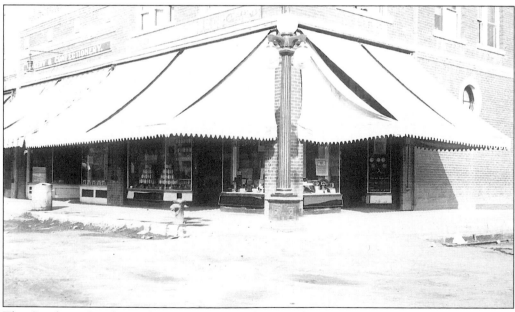

The Southern Pacific Railroad and the Lindsay Land Company founded Lindsay, south of Exeter, in 1888. Its post office was established on October 31, 1889. It has a rich history and is well known for its olive production. Tienken and Smith's Lindsay Drug Company, pictured here in the 1920s, served the community for years, dispensing pharmaceuticals and sundries to local residents. Next door on the left, is the bakery and confectionery.

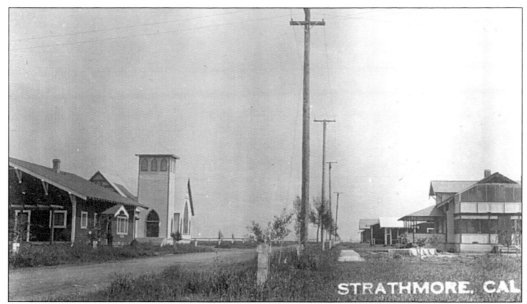

Strathmore is a small Tulare County community located between Lindsay and Porterville. It was first settled in 1878 by Peter Roth, who had huge grain fields in the area. When the Southern Pacific Railroad went through the area in 1888, the wife of the railroad agent named the siding and post office Roth's Spur. The railroad also called it Filo and Santos, but local protests returned the name to Strathmore. This early photograph of Strathmore was taken around 1910, three years after the establishment of its post office.

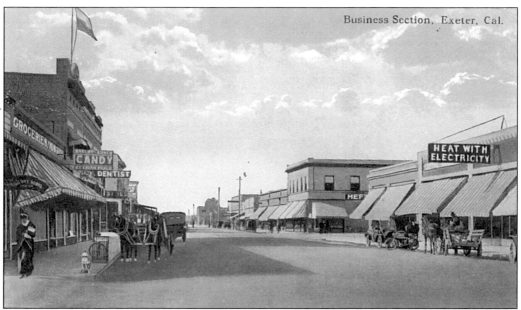

In Tulare County, Exeter is located 10 miles east of Visalia, at the base of the foothills of the Sierra Nevada. This street scene, shown c. 1920, shows Pine Street looking west. On the left is the two-story Brown Building with the flag. It now houses Exeter Antiques. The old Hefton Drug Store is the green two-story building on the right. It is now a flower, gift, and antique shop. Both are still standing.

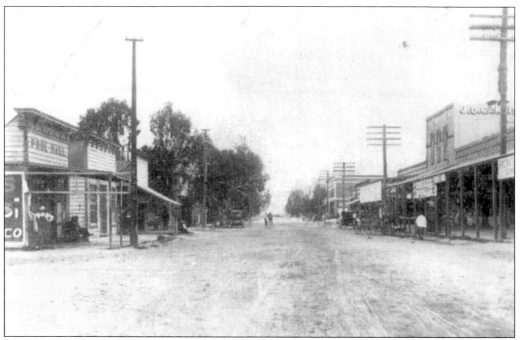

Pine Street in Exeter is seen here in a 1910 photograph looking east toward the mountains. The J.O. Garrison Store and Odd Fellows Hall is the two-story building on right. In the background, on the right, are the old Mixter Building and Brown Building, located at Pine and E Streets.

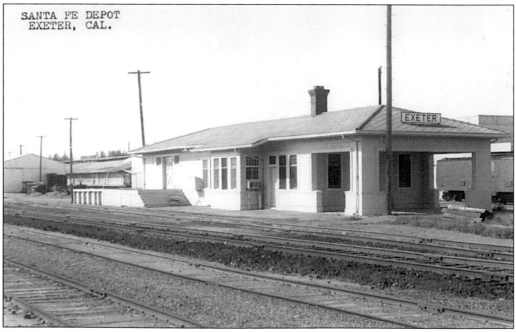

The Exeter Santa Fe Depot handled freight in and out of town for years. It started as the terminus for the Minkler and Southern Railroad in 1914. Although it was built to handle passengers too, that service was not widely used. To preserve the building, the depot was moved to a ranch south of town in December 1996.

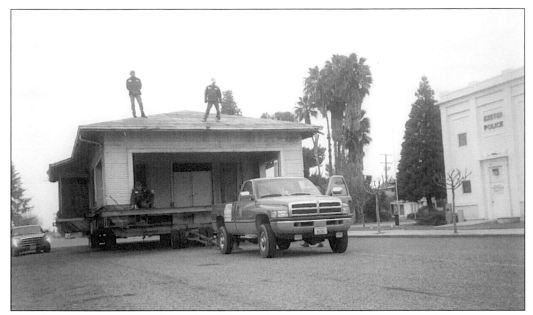

In order to get to the ranch south of Exeter, it was necessary to move the depot past many Exeter landmarks. Here, in front of the old Exeter Police Department building, the depot awaits the pulling power of the author's Dodge Ram 4x4 pickup, which was hooked up to the building to pull it down B Street to South Kaweah.

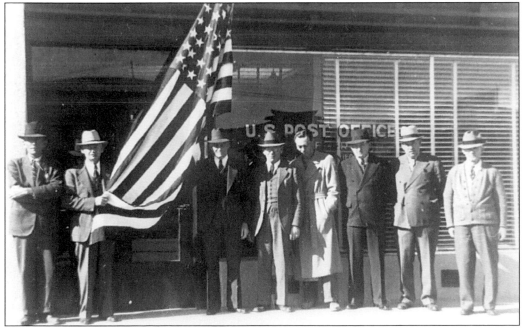

Exeter's post office was established on June 17, 1889, a year after the founding of the community. The dedication of the new Exeter Post Office took place in 1939. The building, located on North E Street, replaced an old post office facility that was literally a room in an old building on Pine Street. L.M. "Bud" James, who owned the adjacent finance company, privately constructed this building.

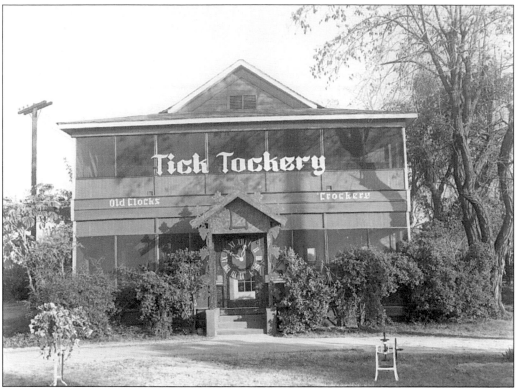

The Tick Tockery was a well-known clock and antique shop north of Exeter. Owned and operated by the Pease family, it held a fantastic collection of clocks and other items.

Memorial Hospital at Exeter was built in 1947 as a small private hospital. It was well known in the early 1950s as a facility to treat polio. This picture shows the facility just after construction on the east side of Exeter.

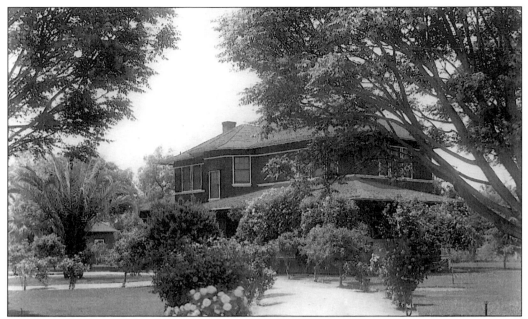

This building, known as the Dofflemyer House, still stands outside of Exeter on Spruce Road. It was constructed in 1906 by Pete Carney, a partner in Exeter's first lumberyard. This 1912 photograph of the house and grounds shows it as a shingled house just after William Dofflemyer purchased it. In 1929, the house was remodeled, and a concrete-like finish was applied to the outside. The tenant house, built at the same time, is also still standing along Spruce Road. Both are reminders of the days of estates in Exeter. At one time, Exeter was said to have had more millionaires per capita than any other community in the United States.

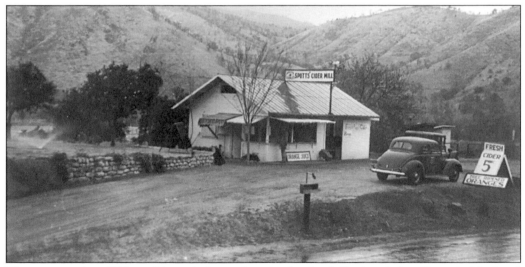

The community of Three Rivers is located up in the foothills, just below Sequoia National Park. Although it is on the east edge of the San Joaquin Valley, it serves as a park gateway community. Hale Tharp settled Three Rivers as early as 1856. The name of the community was suggested in 1879, and the post office opened on December 23rd. This is an early photograph of Spotts's Cider Mill, located beside the road to Three Rivers. Fresh cider was 5¢ a glass, and the oranges were plentiful. The cider mill is still a landmark for local residents and visitors.

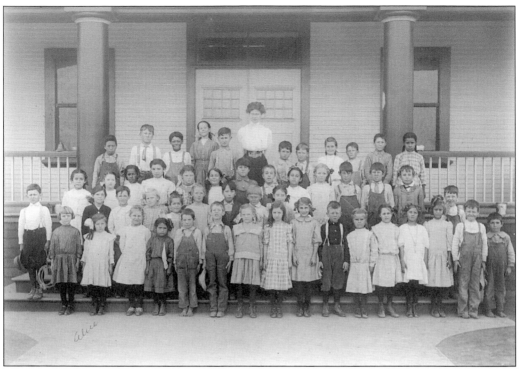

Vine Street School in Porterville saw many children pass through it portals. Here, the teacher, Miss Platt, oversees her well-behaved class posing for the photograph.

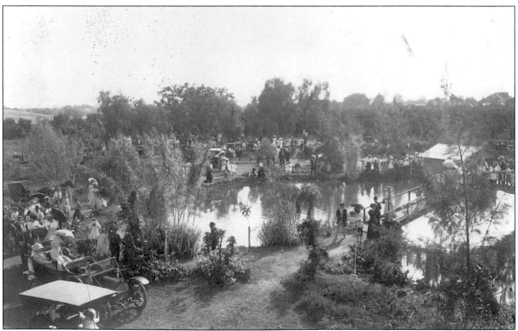

Porterville's Burbank Park is still entertaining residents, such as these locals who gathered in the early 1900s for a holiday celebration. The automobiles in the foreground lend a fascinating insight to early transportation in the area.

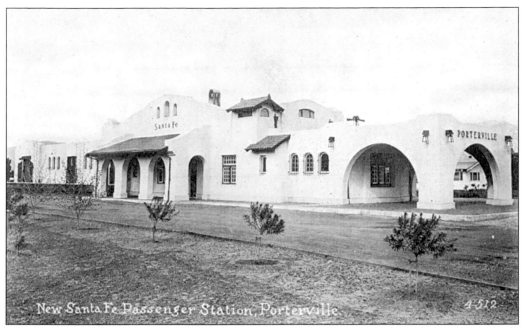

Porterville's new Santa Fe Station shines, with its mission-revival style architecture and tile roof. It is a great example of the grandeur of yesteryear's railroad. Today, the depot serves as a museum for the community.

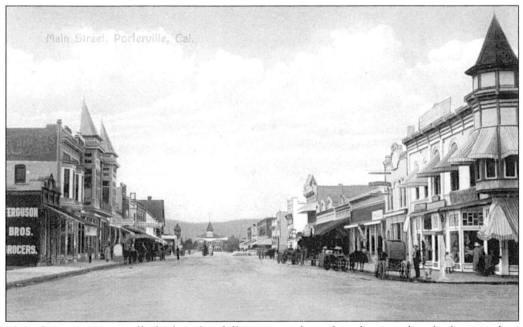

Main Street in Porterville looks a bit different now from this photograph, which was taken around 1910. The Ferguson Grocery store was operating in full swing, and the *Porterville Messenger* was publishing down the street. As with many small towns, the school was located at the end of Main Street.

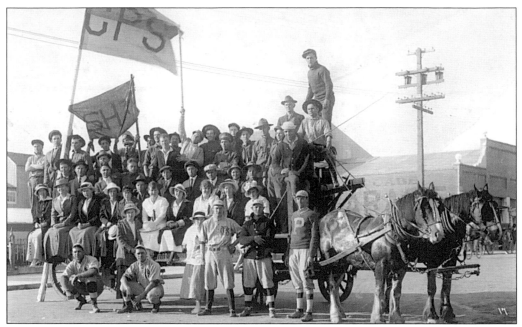

School spirit has always been high in Porterville, as is evident in this early-20th-century photograph of the rival rooters from Delano and Porterville at a local baseball game.

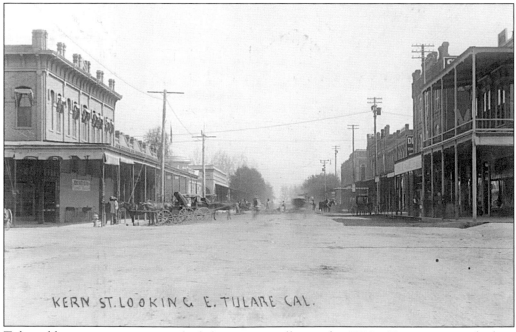

Tulare, like most communities, had dirt streets well into the 1900s. Here is a great look at Kern Street looking east, just after the turn of the century. In the background, a work crew is trenching across the street, laying in water line.

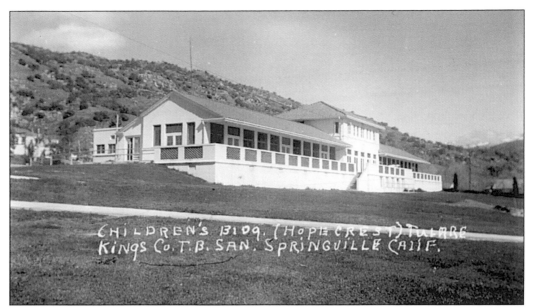

Founded in 1889 above Porterville in Tulare County, Springville was once home of the Tulare and Kings County Tuberculosis Sanitarium, which took care of the many people who fell victim to the dreaded disease. Hopecrest, pictured here in 1941, was the children's building.

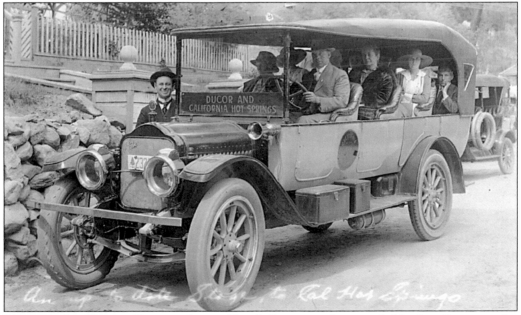

Ducor, south of Porterville, started out as Dutch Corners and was settled by four Germans who had adjoining homesteads and shared a common well. The Southern Pacific Railroad came through in 1888, naming the area El Granado. Its post office was established in 1907, with actual development beginning in 1908. This photograph from 1920 shows the Ducor and California Hot Springs Stage Company's white touring bus that ran between the two communities. It held 11 people.

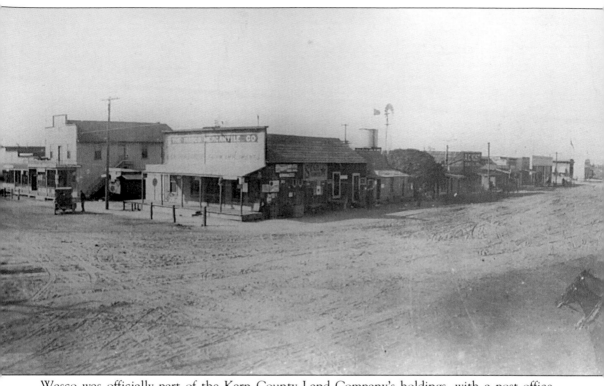

Wasco was officially part of the Kern County Land Company's holdings, with a post office opened on June 2, 1900. It was separated in 1907 as the Fourth Home Colony Extension. The

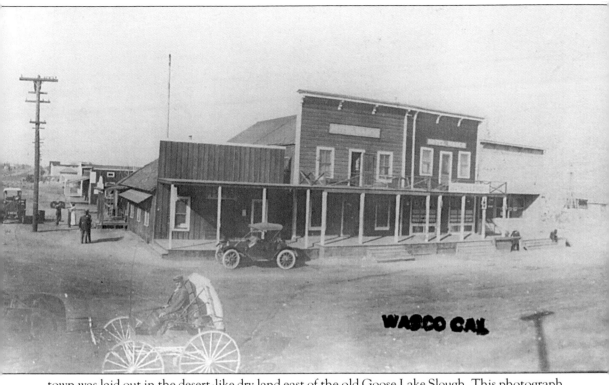

town was laid out in the desert-like dry land east of the old Goose Lake Slough. This photograph shows the community around 1912, with the Wasco Mercantile on the left.

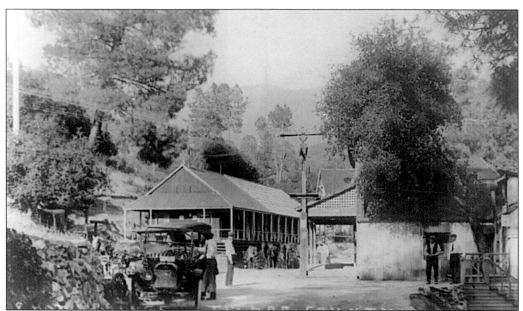

California Hot Springs has been an active resort area for nearly a century, with a post office operating under the name of Hot Springs from 1900 to 1926. Also called Deer Creek Springs, after the American Indian name "del venado," it was settled by the Witt brothers in 1886. Located above Ducor, in the foothills of the Sierra Nevada, its mineral baths have been a haven for Southern San Joaquin Valley residents since 1902. This early photograph of part of the facility was taken in the teens.

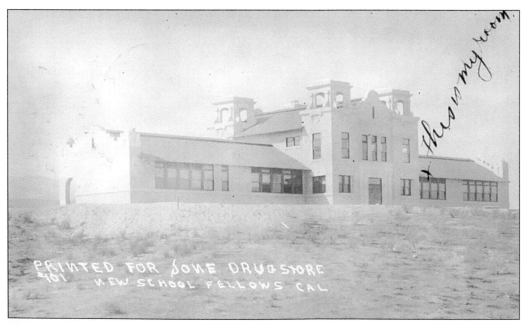

The town known as Fellows was founded in 1910 after the drilling of the Midway Gusher, which blew in 1909, starting the West Side oil boom. In the oil town of Fellows, located in western Kern County, the new school was an important element to the community. This photograph of the Mission Revival School was taken when it was newly constructed.

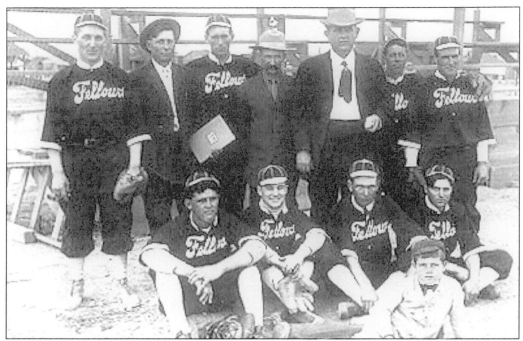

The Fellows community baseball team was made up of strapping young men who came in from the oil fields to play ball. This early baseball team posed for a photograph before their game around 1915.

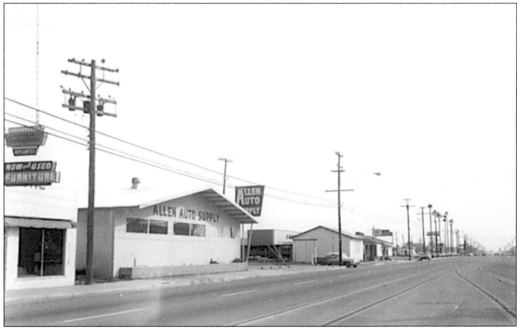

The town of Lamont is located about 12 miles southeast of Bakersfield. Founded in 1923 by Arthur S. McFadden, the community was named after his Scottish clan. This 1965 photograph shows the Weedpatch Highway as a broad street running directly through the middle of town. Allen Auto Supply appears in the foreground.

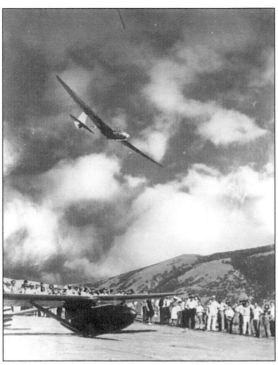

Kern County's Arvin was founded in 1907, named after local storekeeper Arvin Richardson. Its post office was established in 1914. Arvin is now known for its potatoes, but in the past, it was also known for its glider meets. This photograph illustrates one of the meets in the mid-1930s. Note the side of Bear Mountain, visible in the background.

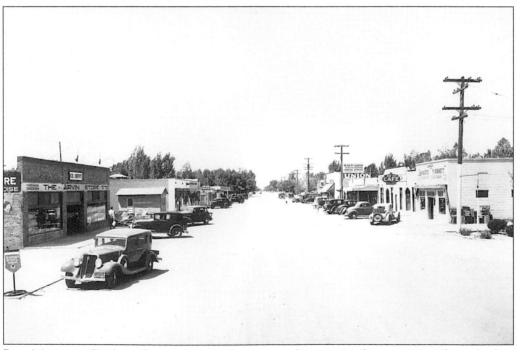

Bear Mountain Boulevard runs through the center of Arvin. In this streetview from the late 1930s, the Arvin Store is visible on the left, and Dan's Quality Market and Mae-Flo's Cafe are visible on the right. Farther down the street is the Bear Mountain Garage, located on the right where the Union sign is. The Sanitary Market and City Paint Store are down the street on the left.

Maricopa is another oil community, located south of Taft, near the Monarch siding for the Sunset-Western Railroad. The post office opened in December 1901, with the community named after the tribe of Arizona American Indians of the same name. This is a photograph of Clarence S. Green and his mount in front of his buggy and saddle shop in Maricopa. The town was incorporated in 1911.

As with any community of size, Taft was not without its own newspaper for long. The *Midway Driller*, the *West Side News*, and the *Pink 'Un* were a few of them. The first newspaper deliveries in Taft were completed by a mule-drawn buggy. Note the mud-splattered sides and wheels, indicating a wet run for the driver.

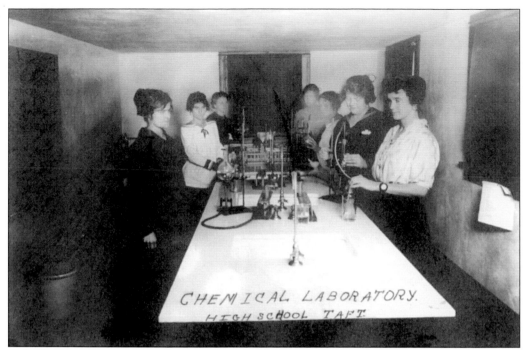

Taft High School was fully operational not long after the founding of the town. This wonderful photograph from 1915 shows one of the then sexually segregated classrooms of the school. Here, female students work in the chemistry laboratory.

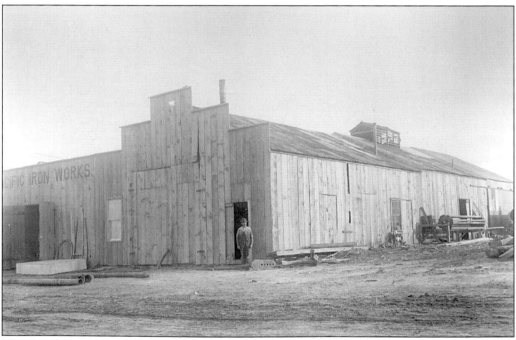

The Pacific Iron Works sits next to the Erb Blacksmith Shop in Taft. These iron-working shops made and repaired much of the oil equipment used in the fields in western Kern County around 1910.

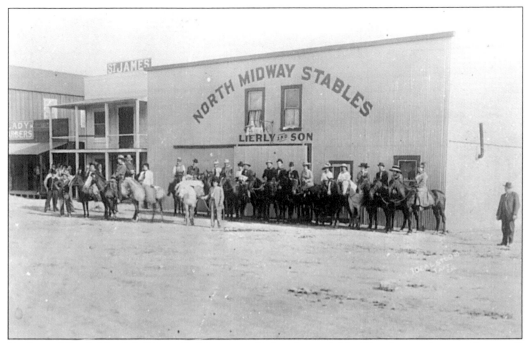

Lierly and Son's North Midway Stables was a fairly substantial facility that took care of most all of the equestrian needs in Taft. This is a March 1911 photograph of a group of riders setting out on a day trek into the Temblor Range and Elkhorn Valley on Kern County's West Side. Men and women are ready to ride, and a mule is loaded with provisions as they prepare to depart. The St. James Hotel is next door, and beyond it is a barbershop advertising "Lady Barbers."

Martha Smith Pixley poses here with friends at the family home. The Frank Pixley family was related to the editor of the *San Francisco Argonaut*. Frank Pixley, with William Bradbury and Darwin Allen, incorporated the Pixley Townsite Company in 1886.

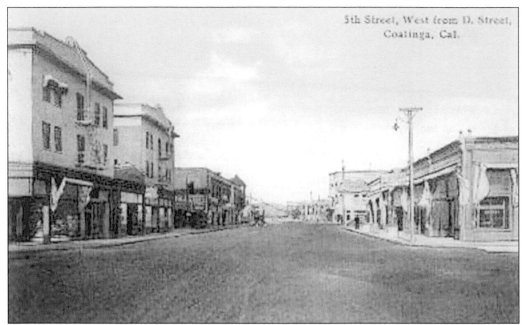

Although Coalinga is in Fresno County, it seems fitting to include it in the Southern San Joaquin Valley history, as it is an important community in the history of San Joaquin Valley oil. This photograph of Coalinga's Fifth Street is a view looking west toward the Temblor Range. Although a great deal of the community was damaged in a devastating earthquake in the 1980s, it has rebounded remarkably.

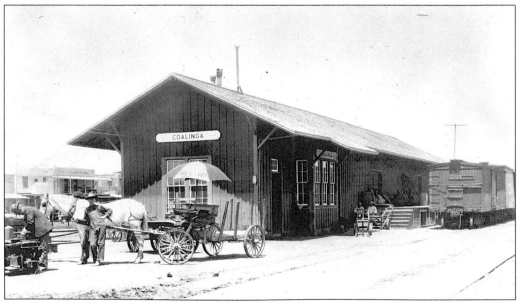

The Southern Pacific Company built Coalinga's railroad depot after they laid in the line in the late 1880s. The post office was established on July 22, 1889. This image depicts the dray service as it existed in the early days of Coalinga. The primitive equipment used to deliver bags and cargo consisted of a horse and wagon. The Eagle Saloon is visible in the background of this early photograph.

Chris Evans was working at the Tipton Warehouse at the time of the famous Tipton train robbery. This photograph shows the warehouse in the 1920s, paralleling the railroad tracks. Note the posters on the walls, including those for Morton's Salt and Prince Albert tobacco.

Fountain Springs, in eastern Tulare County, was another of the Butterfield Stage stations on the old Fremont Trail. The Great Overland Mail, as it was officially called, ran through the east side of the valley, passing through the Fountain Springs station. Fountain Springs had a post office that operated between February 1875 to October 1888. The Fountain Springs station, as it was seen in 1930, is pictured in this view looking southward.

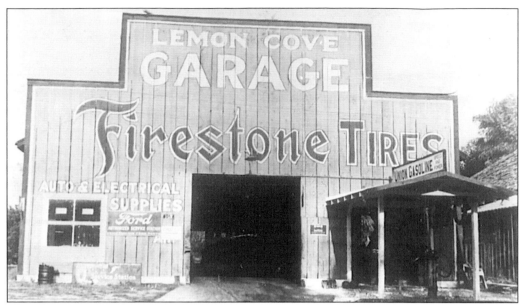

Lemon Cove was originally called Lime Kiln after deposits of lime were found in the area in 1859. It had a post office under that name from 1897 to 1898, when the name was changed to Lemon Cove. Later, the post office changed the name to Lemoncove, to eliminate confusion with other communities. The Lemon Cove Garage served the eastern Tulare County community for years. It provided not only mechanical service for vehicles and farm equipment, but also fuel for the passer-by. This is a great 1930s picture of the garage, complete with gasoline pumps.

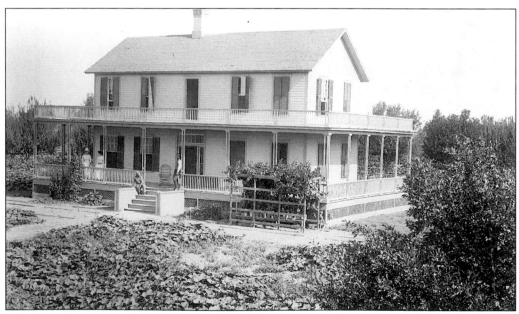

The Kern County Land Company's Panama Ranch was another of the sizable ranches held by the partnership of Haggen, Tevis, and Carr in the 1880s. Located in a very fertile area of the Kern Delta, the ranch, south of Bakersfield, was not one the largest of the company's holdings. This photograph shows the ranch house, with its full first and second-story porches.